VERMEER

PIERRE CABANNE

Cover: **The Girl with a Pearl Earring,**

c. 1665-66,

oil on canvas, 44.5 x 39 cm,

Mauritshuis, The Hague.

Translation: John Tittensor
Design: Sandrine Roux/Caroline Keppy
Picture Editor: Édith Garraud
Editorial Director: Soline Massot
Copy Editor: Kate van den Boogert
Photo-Engraving: Grafiche Zanini, Italy

Publication N° 304,
ISBN: 2-87939-277-2
Printed in Italy.

© Éditions Terrail/SN des éditions Vilo, Paris, 2004.
25, rue Ginoux, 75015 Paris.

PIERRE CABANNE

VERMEER

TERRAIL

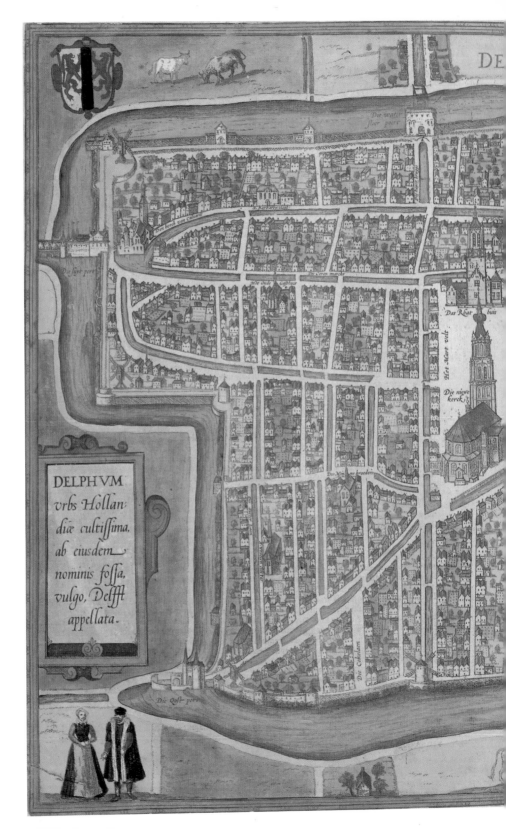

DE

DELPHVM
vrbs Hollan:
diæ cultiſſima,
ab eiusdem
nominis foſſa,
vulgo, Delfft
appellata.

Die watr
ſloer port

Die ſure port

Den kerck van Cal

Het Marct Geſſt

Hee Oude Gaſthuus

Spen Merckt

Das Khat huit

Het Mart velt

Die nieve
kerck

Die Molnar broeders

Die Coketten

Die Roſt port

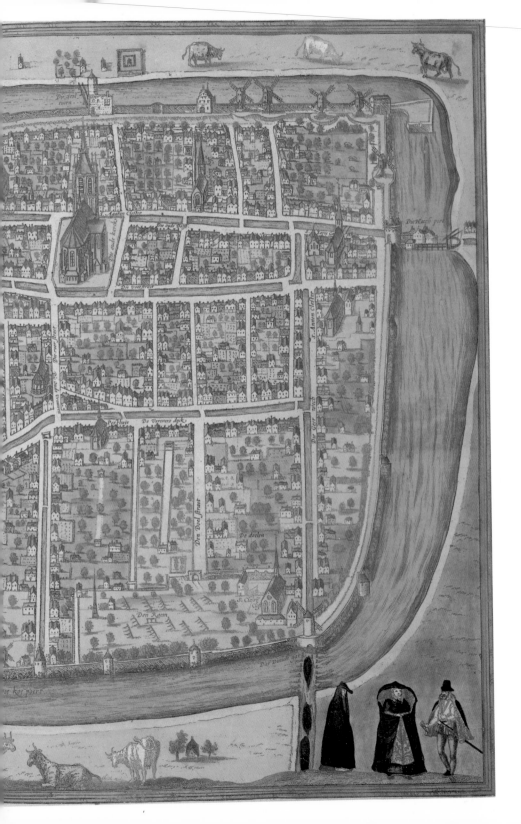

contents

Previous pages:
After Joris Hoefnagel (1542-1600)
Map of Delft, taken from Civitates Orbis Terrarum
by Georg Brau and Fraus Hogenberg, 16ᵗʰ century, color engraving,
private collection.

In Delft
a painter of rare gifts
— but no pictures

One summer's day in 1663 Balthazar de Montconys, adviser to the King of France, found himself in Holland in the course of a tour of Europe. After a visit to Delft — or Delphe, as he called it — he went on to The Hague and returned on 7 August, charmed by the city's "canals lined with trees and hedges, its little woods, its many houses and several water-powered sawmills". On a further visit on the 11th, "I saw the painter Van Meer, who had no work at all to show me." Nonetheless he found one painting, in a bakery: "It had cost 600 livres, even though there is only one figure in it. In my opinion the price was six pistoles too high…"

A strange case this painter, already famous in Delft, dean of the very active St Luke's Guild — the painters' guild — for a year, then subdean for another year, but with nothing in his studio. Montconys went to see two other well-known painters, Frans van Mieris and Gerrit Dou; they too had very little to show, except the odd picture they had at home.

Delft at the time was Holland's third-largest city and famed for its splendid earthenware, whose richness of color was obtained by coating the basic tin glaze, after decoration, with a uniform layer of clear glaze. Blue monochrome Delftware with flowers or figures was much sought-after. Although they drew their inspiration from Chinese porcelain brought back by explorers, the local ceramicists showed great originality and inventiveness in their imitation of subjects taken from everyday life in China.

The city had a stormy past, with savage clashes between Calvinists and Catholics. When the 1579 Treaty of Arras left the northern provinces in the hands of the Protestants, their coreligionists in the south, who had suffered greatly under the conquering Spanish, moved northwards.

The social model for 17th-century Holland was Calvin's Geneva. The Dutch were canny merchants, and for the Reformers accumulating wealth — and not spending without good reason — were in harmony with the ways of Providence. This was an austere society where the domestic virtues prevailed in orderly interiors; and if the menfolk sometimes drank a little too much in the taverns, their wives looked after the family home and conscientiously did their duty as mothers. Work, whether

Among these masters whose work and whose names we recall with such pleasure — Dou, Mieris, Ter Borch, Metzu and others — one in particular stands out. Not necessarily greater, for greatness is not the issue here, but more perfect, rare and exquisite; and if other adjectives are needed, we must turn to the English language, to 'eerie' and 'uncanny'. Here then is his name: Vermeer of Delft.

Paul Claudel, Eye Listens, 1946.

manual or intellectual, was highly valued, and human weakness kept in line by a strict moral code; courting couples communicated while making music together or via discreet exchanges of letters. And apart from a few slightly daring scenes in the oeuvre of Jan Steen, anything resembling libertinism was kept well in check.

Since images were forbidden in Protestant churches, there were no more ecclesiastical commissions and so artists worked for the wealthy, who liked to decorate their homes with "well finished" genre paintings. This did not make artists rich, however, and if Montconys found a Vermeer in a baker's shop it may have been that the painter had cleared a debt that way. After his death his wife settled the balance with two more pictures.

The Calvinist bourgeoisie was fond of meticulously realist work executed in the calm of the studio, but in addition to confirming their social status and religious beliefs, art helped them to discover and value their identity. They saw themselves living, feeling and acting in pictures that eschewed the voluble expressiveness of the South, and in which, apart from an occasional vividly misty landscape or a charmingly voluptuous body, there were hints of the self-interrogation and the restless urge to learn that would see Rembrandt questioning his own face all his life.

Close to thirty years Rembrandt's junior, Vermeer opted for the serenity that came from thinking about being and about spiritual reality. His was a painting of the mind, in all its mystery and torment — but out in the light: never one for shadow and darkness, or journeys to distant lands, he set his gaze on the horizon of his natal city, with its pearl skies and shimmering water. A quirky geometry gives a certain strangeness to these compositions, in whose real, everyday space the artist seizes time's silent suspension, halting an ordinary moment of life in midflight and imposing the static orderliness of dense yet fluid texture. Here are the idealized clarity and stability that would be rediscovered four centuries later in the abstract work of Mondrian.

Unlike the painters of the South — particularly their Italian contemporaries — those of the North had a positive approach to things. Bourgeois working for the bourgeoisie, rather than for princes or the Church of Rome, they were open to other influences — and above all to Caravaggism, the source of a sometimes overstated naturalism and assertiveness. They would go on to find their own sensibility, all delicacy and discretion, among the painters born in 1610-20, of whom the finest representative is Gerard Ter Borch the Younger. Then came the generation of the 1630s and amid all this plenty is a painter of rare gifts but no pictures. In a career lasting less than 25 years Vermeer painted only some 60 works of which maybe 35 have come down to us, each of them perfect in its kind: the present — spatial or temporal — is rendered in all its simplicity and eternity.

Around the motionless subject lives the light.

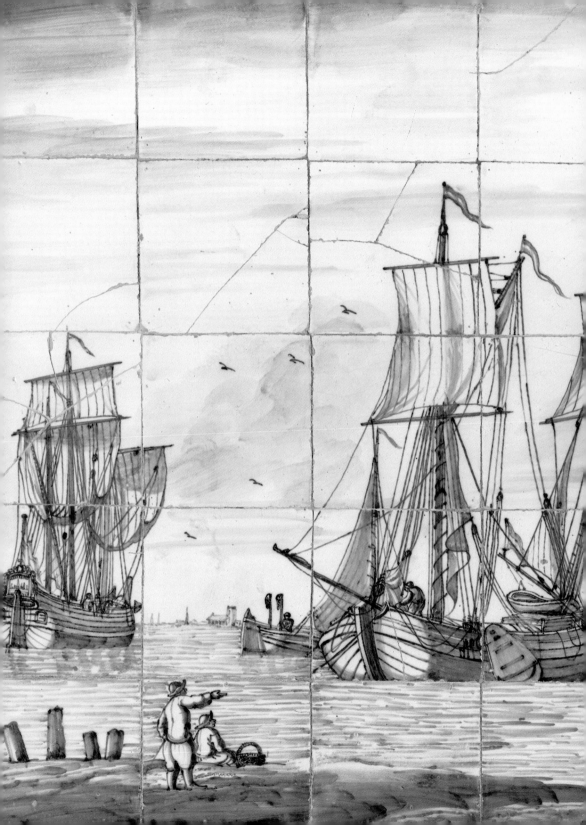

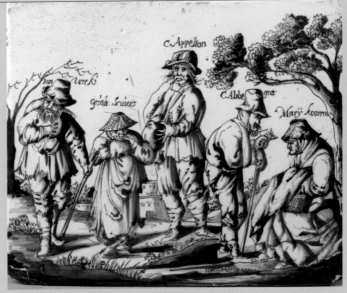

Anonymous

Les Gueux: l'Avare, la Lavandière, Marie Blé,
c. 1650-60,
Delft earthenware, blue monochrome, 18 x 22 cm,
National Ceramics Museum, Sèvres.

Attributed to Cornelis Boomeester
(1652-1733)

ceramic tile panel: seascape,
17th century,
Delft earthenware, 66 x 78.6 cm,
Musée des Beaux-Arts, Lille.

Jan Steen (1626-79)

Woman at Her Toilet,
1659–60,
oil on canvas, 37 x 27.5 cm,
Rijksmuseum, Amsterdam.

Born in Leiden, Steen made
his reputation with popular
genre scenes whose frankness
took him far beyond anything
the more decorous Vermeer
ever dared to show.

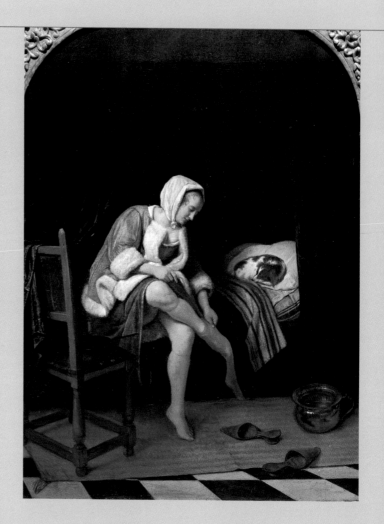

Time, work and shrewd husbandry

From the closing years of the 15th century to the end of the first decade of the 16th, new ideas and forms were born and developed in Italy. From Florence, from Rome where Classicism was honed by circumstance, from vividly sensual Venice, they moved out into the rest of Europe. In 1630-40 came the Baroque, born out of the Renaissance and bringing to art the spirit and the doctrines of the Counter-Reformation as initiated by the Council of Trent in 1545-63.

This brought the artist new status. Now living in a climate of intense intellectual activity, he was no longer a modest craftsman and guild member. As the commissions flooded in and he found himself among wits and thinkers, he wanted to be seen as knowledgeable, scholarly even; he frequented the academies, was treated on a near-equal footing by kings and princes and was sometimes on friendly terms with popes.

Not so in the Calvinist low countries where the artist's task was to portray a form of self-absorption within a limited world, to show the world's enduring riches – the landscape, the city, the sky, the sea – and its more ephemeral pleasures: personal dreams or the domestic and civic virtues. The most prized genre was the portrait, that mirror in which the affluent bourgeoisie, civil servants, merchants, lawyers, the military and members of guilds and brotherhoods called on painters to capture them for posterity, in the company of their wives and children, in all their economic success, marital bliss or social standing.

The artists were not indifferent to the new ideas, especially those coming from Italy – although they saw no pressing need to go there. The journey was a long one, but apart from this, keeping your distance could also mean keeping your liberty. The men of the North set great store by professional standards, by a measured, meticulous process that made the most of their materials and ensured technical perfection. There was no trace of the bohemian about these shrewd husbanders of time and work, no intellectualism in their inventiveness – and no erudition, as their inventories show. Vermeer's ran to a few pictures, three of them by Fabritius, some furniture, a suit of armor, a helmet and a "Turkish cloak", and various household and work-related items. No books.

The initiator: Carel Fabritius

A former pupil of Rembrandt, Carel Fabritius had settled in Delft on marrying for the second time. His presence there is attested to in 1651 and in the following year he joined the St Luke's Guild. He adopted the precise and objective local style of painting, but added illusionistic procedures and new forms of light-contrast. Respected as a "painter of perspectives", he is said to have used peep-boxes. This would seem to be the case of his curious *View of Delft*, with its double vanishing point and prominent left foreground.

It was with these peep-boxes that Delft created a new genre: illusionistic perspective applied to church interiors. Saanredam, of Haarlem, was the first — around 1630 – to bring mathematical exactness to the portrayal of architecture, although this does not exclude a pleasingly intimate, poetic feel in which atmospheric limpidity is conveyed via a pale palette largely made up of whites and grays. Emanuel de Witte, in Delft in 1654-55 before leaving to live in Amsterdam, was another specialist in interiors of religious buildings. His carefully studied perspectives, the extensive black-and-white tiled areas, and the feeling of calm and silence are all found in the work of de Witte's teachers Gerrit Houckgeest and Hendrik van Vliet. And all these painters were part of the movement that included Fabritius, whom Vermeer himself would draw on.

Fabritius died tragically in 1654 when fire broke out in a powder magazine near his home, an event commemorated in a 32 line poem by the Delft bookseller Arnold Bon:

> *Thus did this Phoenix, to our loss, expire,*
> *In the midst and at the height of his powers,*
> *But happily there arose out of the fire*
> *Vermeer, who masterfully trod in his path.*

In another translation the last line runs,

> *Vermeer, who masterfully outdid him.*

These lines give weight to the theory that Vermeer had been both Fabritius's pupil and continuator, and that he was an extremely well-known figure in Delft. But who was this painter first publicly mentioned in a naive elegy, printed by Arnold Bon in Direck van Bleyswyck's *The Description of Delft*?

Joannes Vermeer was born into a family that can hardly be described as distinguished. His maternal grandfather Balthazar Gerritz was a "merchant's assistant" who had been mixed up in shady financial dealings before becoming implicated in a counterfeiting affair in The Hague. In 1615 Gerritz' daughter Digna

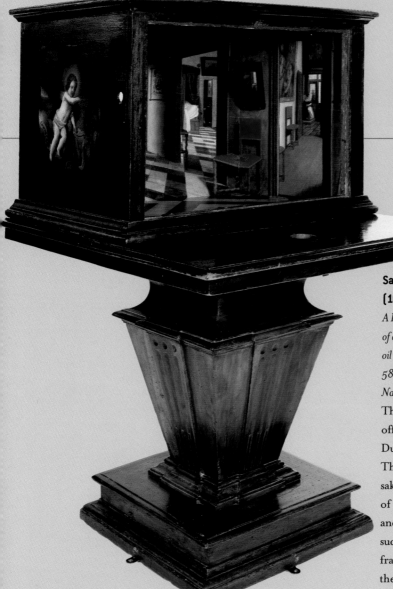

**Samuel van Hoogstraten
(1627–78)**

*A Peepshow with Views of the Interior
of a Dutch House, 17th century,
oil and egg tempera on wood,
58 x 88 x 63.5 cm,
National Gallery, London.*

This jewel of the art of perspective
offers the viewer the interior of a
Dutch house in three dimensions.
This is not illusion for its own
sake, however: while the painters
of the time – including Fabritius
and Vermeer – often made use of
such optical artifices as lenses, glass
frames and the camera obscura,
they considered perspective as a
means of recreating reality as
faithfully as possible, and not as an
end in itself.

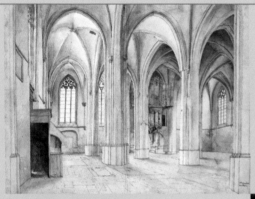

Below:

Emanuel de Witte (1617-91)

Interior of the New Church, Delft
1664,
oil on canvas,
Residenzgalerie, Salzburg.

Above:

Pieter Saenredam (1597-1665)

Interior of the Church of St Cunera in Rhenen,
1644,
pen and brown ink, 40.8 x 54.4 cm,
Frits Lugt Collection, Institut Néerlandais, Paris.
The specifically Dutch church interior
genre appeared in the 17th century. Like
Emanuel de Witte, Gerrit Houckgeest
and Cornelius de Man, Saenredam
delighted in portraying everyday activity
inside churches amid the perspective
provided by columns and vaults.

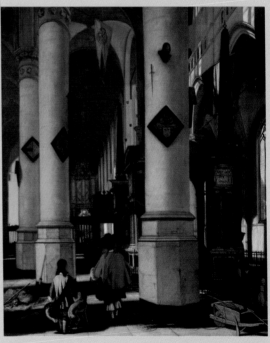

married Reynier Janszoon, a Delft weaver of modest means, and the couple lived in the Broerhuis neighborhood until Reynier became the landlord of the Flying Fox inn in Voldersarach. This neighborhood was the source of Janszoon's cognomen Vos or Voos or Vosch, which appears, alongside Vermeer, in the baptismal certificate of one of his nephews, Reynier Janz Vermeer, alias Vos. Reynier and Digna had a daughter, followed by a son Joannes, whose birth was registered on 31 October 1632 at the Nieuwe Kerke, the New Church. Joannes would be known to posterity as Jan Vermeer of Delft.

To write about Vermeer – to explain his genius, go to the heart of his "mystery", crack some secret or other – is a difficult, if not impossible and maybe pointless task. His life was relatively short and uneventful, yet his oeuvre – long ignored or dismissed as minor – is one of the most fascinating in the entire history of painting, the result of concentrating on a few simple themes, a technique that renders the merest detail almost palpable, a distinctive grasp of space and time, and a light that is the essence of timelessness.

One of the main inspirations for Vermeer's painting was the theater, which was extremely popular in 17th-century Holland, especially when the content was musical. Some Vermeers are faithful reproductions of scenes from the stage of his time, yet rather than exploiting a genre, he was revealing, via the singularities and details of his pictures, a whole microcosm of conversations, meetings, musical duets, intrigues and even lovers' break-ups. As in the theater, the focal point was the couple and the setting the restricted one of a domestic interior. But in what appear to be simple episodes from private life, we find a wealth of symbols; and when Vermeer was rediscovered in the 19th century – at the time of Courbet and Manet – and acclaimed for his realism, it became clear that his oeuvre embodied a highly distinctive psychology and moral code.

The unsettling impression of serene unreality is that of the stage, not of life as such. Everything here is pretense and calculation: the gestures have a ceremony about them, and the feelings are not the everyday ones of the painter's contemporaries, but reflections of certain conventions. We do not see Vermeer's people taking action, rather we guess at and judge their intentions. Wrongly, no doubt. In his life as in his pictures Vermeer remains a great, incomplete, and eternally haunting figure.

Caravaggism
and the Utrecht School

Vermeer grew up in the noisy, smoky atmosphere of his father's inn, where brawls were a common occurrence. In March 1641, Reynier acquired the Mechelen Inn on the marketplace in the center of Delft, the busiest area of the city. A few years earlier, in addition to his trade of innkeeper, he had become an art dealer and it was in this capacity that he became a member of the St Luke's Guild. This meant contact with the local painters, some of whom had considerable reputations, and his son met them as well.

Reynier was no business genius and the rest of his family hardly more gifted. They helped each other out as best they could, but when he died in 1652 his wife was left with all sorts of problems. It is not easy to know what young Joannes did then. He might have become an apprentice, but to whom? To Carel Fabritius, according to tradition – but apart from the lines by Arnold Bon, there is no proof at all. And Fabritius only became a guild member in Delft in October 1652, too late to have been Vermeer's master.

In the following year, on 5 April 1653, Joannes married Catherina Bolnes, from a well-off Catholic family from Gouda. They were married in the Catholic church, Vermeer converting to his wife's faith and moving with her into Oudelengendijck, the "Papist" quarter of Delft, in a house belonging to Maria Thins, Catherina's separated mother. This was a happy and apparently problem-free couple. But what exactly was Joannes doing for a living? On 29 December 1653 he was admitted to the St Luke's Guild, but at that time could only meet part of the membership fee and paid the balance later.

So Vermeer was already a painter. But where did he learn his craft, and when did he begin? When Fabritius died in 1654 after the explosion near his studio, he left a substantial but not very diverse body of work; Vermeer's oeuvre has been scoured for signs of his influence, but people find what they want to find... Still, Vermeer may have been inspired by Fabritius, three of whose pictures were among his property when he died.

The young Vermeer was curious and fascinated by novelty, but these characteristics were shared by other Dutch painters of the time, for whom the supreme genre was the historical painting. True, they boasted of being able to work in other styles, but in provincial Delft, which lacked contact with the main pre-1650 art centers – Amsterdam, Haarlem, Utrecht and Leiden – the painters lacked confidence. Furthermore the bourgeois Calvinist culture trapped them in a certain conservatism – despite the example of the boldest and most famous of their contemporaries, Rembrandt van Rijn, whose pupil Fabritius had been.

So painterly ambitions in Delft were not lofty. Excepting Leonaert Bramer, originality was not the local strong point. Bramer had spent ten years in Italy and returned to his native Delft under the dual influence of Rembrandt and the Caravaggists of Utrecht – lighting effects that set the figures in sharp contrast against a dark background. Interestingly, he had been one of the witnesses at Vermeer's civil wedding.

It was doubtless through Bramer, then, that Vermeer got to know the Utrecht School, heavily influenced – like the rest of Europe – by Caravaggism. Gerrit von Honthorst had brought back the same influence in 1620; he too had lived for ten years on the banks of the Tiber and had probably been in contact there with skilled approaches to light and contrast, and dramatic foreshortening. Caravaggism did not stop at chiaroscuro, however, its everyday naturalism, with an emphasis on facial types and expression, injected a kind of vernacular truthfulness into religious themes. Rembrandt, like Franz Hals, was struck – and inspired – by this.

When Honthorst abandoned Caravaggism for a clearer, more classical, brighter style, the Utrecht School lived on in the form of minor artists whose most interesting representatives were Van Baburen, unfortunately dead at 34, and Hendrick Terbrugghen, an exponent of a subtle mellowness of color that did not exclude the delicate interplay of light. His most typical work, *Jacob, Laban and Leah* (1628) is now in the Wallraf Richartz Museum in Cologne; and the striking lighting of his *Mars Sleeping,* in the Central Museum in Utrecht, is a fine mix of the dramatic and the psychological.

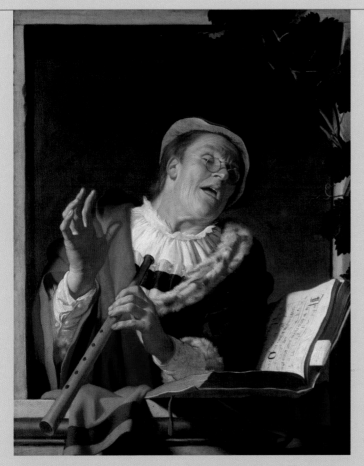

Gerrit van Honthorst (1590-1656)

Cornet Player,

1623,

oil on canvas, 107.5 x 85.5 cm,

Staatliches Museum, Berlin.

This Utrecht painter and etcher
trained in Rome under the influ-
ence of Caravaggio, but later
developed his own style. Working
at the English court he produced
genre paintings and portraits,
retaining the warm color con-
trasts, the popular realism and the
skilful use of foreshortening
favored by the Caravaggists.

Diana and Her Companions,
c. 1654–56,
oil on canvas, 97.8 x 104.6 cm,
Mauritshuis, The Hague.

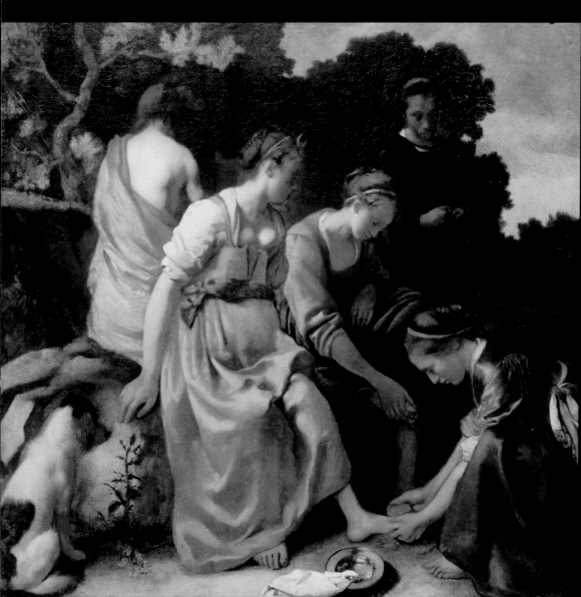

Jacob van Loo (1614-70)

Diana with Her Nymphs,
1648,
oil on canvas, 136.8 x 170.6 cm,
Staatliche Museen, Gemäldegalerie,
Berlin.

Florentine Renaissance "history painting" was a much appreciated genre in Holland, where it drew its inspiration mainly from mythology and the Bible.

The first
historical
paintings

While he was learning the lessons of Caravaggism from these painters – to one of whom he was apprenticed – Vermeer also picked up a repertoire of subjects with musical themes; some of them inspired him, but at a more personal, more delicate level than was the case for his predecessors.

Other artists may also be among his influences, among them the Flemish painter Erasmus Quellinus, who worked on the decoration of Amsterdam's city hall and whose *Christ in the House of Martha and Mary*, now in the museum in Valenciennes, France, Vermeer certainly saw. Amsterdam was very close to Delft and the horse-drawn passenger barges made the journey simple. In Amsterdam Vermeer also knew Jacob van Loo and other painters, whereas he had few affinities with those of Delft and had little to do with them.

Out of these meager sources of inspiration, among which Bramer's Italianism looms largest, would come Vermeer's first two known works: *Diana and Her Nymphs* (1654) and *Christ in the House of Martha and Mary* (1654-55). Mentioned in an inventory of 1657, *The Visit to the Tomb* is now lost. All three are historical genre paintings.

But perhaps, if we are interested in Vermeer's beginnings, we should look at Adam Pijnacker, who set up house in Delft in 1649, after five years in Italy, but then moved to Amsterdam. Along with several other painters of the same generation he belonged to the classical phase of those Italian-influenced Dutch landscape artists who later adopted a more spirited style characterized by lighting contrasts, sometimes of a decidedly Romantic order.

Jan Steen, from Leiden, lived in Delft from 1654 to 1656. His unruly life finds expression in a vernacular vigor he does not always succeed in excluding from his religious scenes, but his warmth of color and his lighting effects have a distinctive force. He was certainly the first Dutch painter – before Vermeer – to draw inspiration from the theater, especially the comedies and farces of Amsterdam poet Gerbrand Adriaen Bredero. Two of Steen's pictures illustrate the tragi-comedy *Lucelle*, showing the young heroine making music with Ascagnes, the disguised prince who is in love with her.

This same scene would inspire Vermeer's *The Music Lesson*, now in the Frick Collection, New York: Lucelle's confidante has succeeded in bringing together the

Christ in the House of Martha and Mary,
c. 1654-56,
oil on canvas, 160 x 142 cm,
National Gallery of Scotland, Edinburgh.

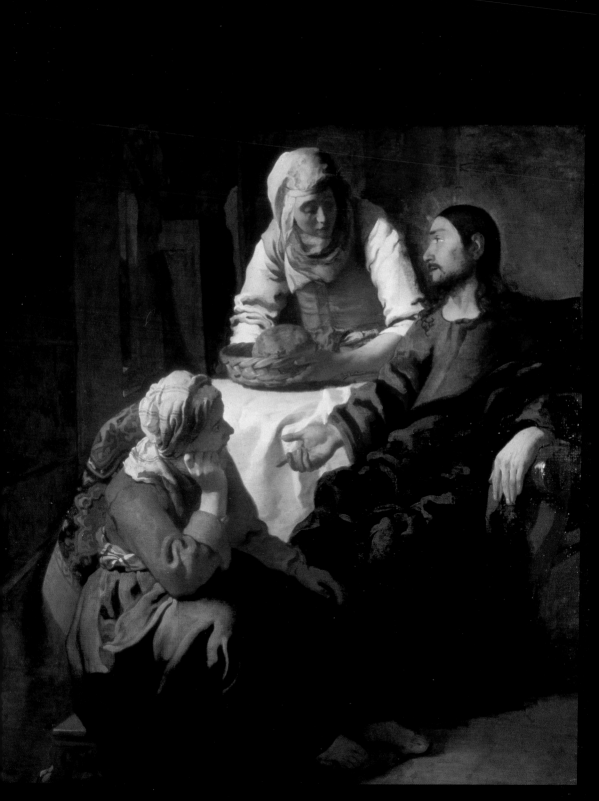

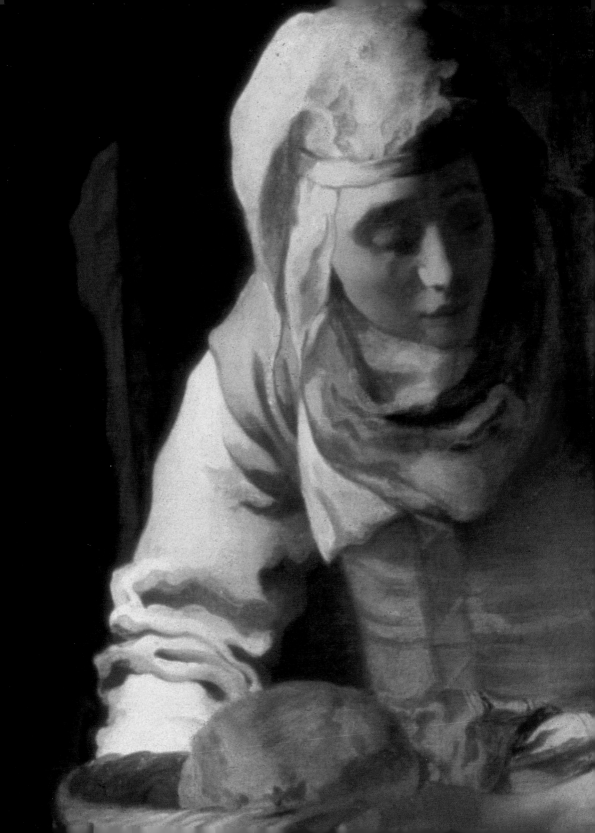

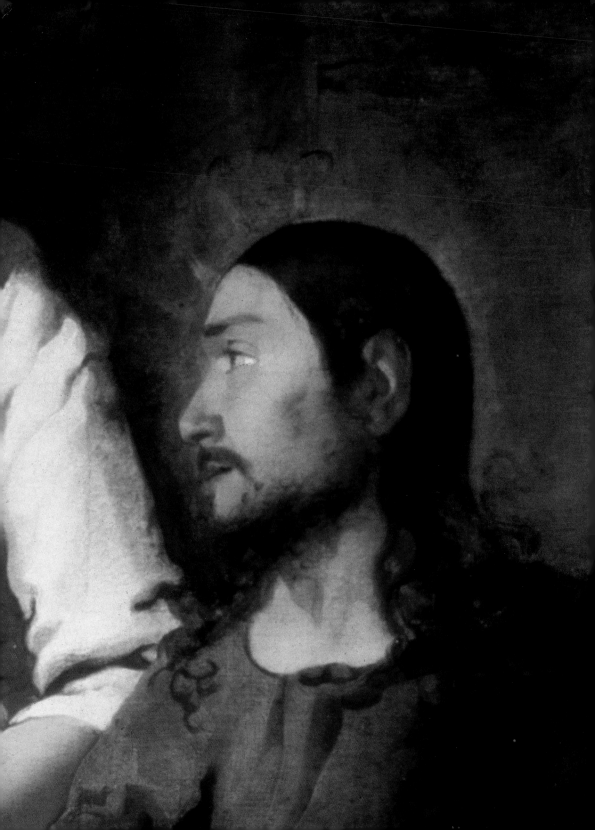

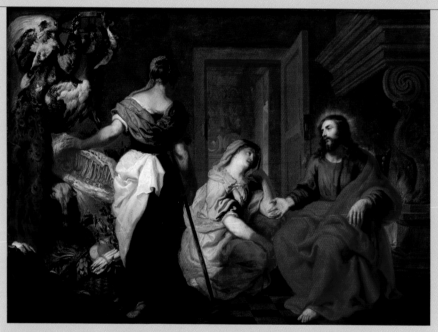

Erasmus II Quellinus (1607-78)

Christ in the House of Martha and Mary,
c. 1645, oil on canvas, 172 x 243 cm,
Musée des Beaux-Arts, Valenciennes.

This Flemish imitator of Rubens achieved fame with his decoration of the new Amsterdam City Hall. Many artists drew on the episode in Luke 10:38-42 in which Martha, busy with household affairs as Mary listens fervently at Jesus' feet, says, "Lord, dost thou not care that my sister hath left me to serve alone?" To which Jesus replies, "Mary hath chosen that good part, which shall not be taken away from her." Painted some years prior to the Vermeer version, Quellinus' picture is a mere dialogue: the master of Delft, by contrast, uses the play of light and a simplicity of gesture to turn the scene into one of veritable interpersonal communion.

amorous prince and her mistress, on the grounds that he must tune her lute and give her a music lesson. Things are not quite so simple in the play, for the wicked valet Leckerbeetje betrays them, but of course, all turns out for the best and Ascagnes and Lucelle are married.

Another leading light of the Dutch theater was Joost van der Vondel, whose best-known play was *Sysbreght van Hamstel* (1632). Bredero's *The Spanish Brabanter* of 1617 was also a great success, but this author of comedies and popular farces was to die prematurely at only 33.

It is not at all surprising that Vermeer and other Dutch painters should have turned to the theater for inspiration, for it was extremely popular in Holland, where tours by companies – mostly French – came in quick succession. From the stage to the canvas the characters and situations were often the same. People play music, lovers' trysts take place over a tempting glass of wine, knowing servants pass on love letters, the dialog often takes the form of sentimental songs or ariettas, and characters dream aloud sitting at their virginals.

Between the picture and the stage actions and feelings move back and forth, giving each other cues; for Vermeer the theater was a place where daily life could be transformed into stories full of surprises and new developments. In the theater his imagination, limited to a narrow provincial and family context in which his only models were his wife and children, found new contexts, new subjects.

It is on stage, for example – in Bredero's *Roderick and Alphonsus* – that he saw a young woman, Elisabeth, read two long letters, one from Roderick, the other from Alphonsus, just as we see in *A Girl Reading a Letter by an Open Window*, now in Dresden, and *Woman in Blue Reading a Letter*, in Amsterdam. However, what is read discreetly in real life becomes something else at the theater: confidential letters are read aloud in a way designed to captivate the audience or surprise them. Which is just what the pictures do, too.

Thus scenes and characters come straight from the comedies then in vogue written by Bredero, Vondel and many other lesser known but equally popular authors. And this was the case not only in Amsterdam, where La Piquerie was the most fashionable theater, but also in most of the Dutch cities on the tour circuit – Delft among them, no doubt. Sometimes the plays, especially the farces, were close enough to shameless for the consistory of the Church of Amsterdam to take action and even ban outright: such was the case with Vondel's *Lucifer*. But then Vondel had shown a lamentable lapse of taste in converting to Catholicism!

In the theater, musical performances and sentimental songs functioned as part of lovers' games, which thus found expression via allusion or innuendo. It was rare indeed that a comedy did not feature a lady playing a lute or a singer of romantic ballads. *The Love Letter*, in

the Rijksmuseum in Amsterdam, is no doubt a transposition of a theater scene: a not-so-young lady receives from her knowing servant a letter that interrupts her performance on the cittern, and surprises her. In dramas letters were often key devices of the plot, as the playing of music was in Romantic dramas.

Although the women Vermeer used in his paintings were provincials or simply models, they often wear pearl necklaces, earrings or trinkets. The explanation is simple: they were actresses wearing the jewelry called for by their parts. In the theater everything is pretence and dissimulation — as in the paintings.

The mysterious musician:
Vermeer?

Three years Vermeer's junior, Pieter de Hooch adapted Caravaggism's recipes to the treatment of light. From 1653 to 1662 he lived and worked in Delft, painting scenes of family life. Doors and corridors open onto views and sometimes two doors open in opposite directions in a way that complicats the perspective, giving the painter the chance to show his skill with light.

There are many resemblances between de Hooch and Vermeer's works of 1658-60, when the latter had still not begun his mature work. Characteristics of de Hooch's Delft period to be found in Vermeer notably include the handling of interior scenes, the relationships between figures and objects, broad areas of light and the use of off-center perspective.

Vermeer, however, would go deeper inside reality: from his very beginnings we can imagine him among the other painters in Delft, looking around and measuring, in terms of his own temperament and ambitions, the inspiration to be drawn from others and input coming from elsewhere. Weighing up the decoration of apartments, the slowness of gesture, the weight of objects. And giving equal attention to framing and lighting.

Pieter de Hooch (1629-84)

Going Out for a Walk,
undated,
oil on canvas, 72 x 85 cm,
Musée des Beaux-Arts, Strasbourg.

Born in Rotterdam, de Hooch worked in Delft c. 1655-61, setting out to compete with Vermeer as a genre painter. However his scenes of family and urban life, with their multiple perspectives, off-centre points of view and contrasting light sources, lack the skill and charm, the intimate eye and the pure, pared-down interiority achieved by his rival.

"From the outset Vermeer painted with incredible power, precision and intimacy of tone. The magic of the diorama was achieved without recourse to artifice.

Théophile Gautier in Le Moniteur, *1858.*

Before becoming Vermeer, Joannes was a man less of hasty discoveries and strokes of genius than of synthesis, tranquilly bringing together interpretation and expression in the highly personal way that would ensure the growth of his prodigious genius. For him light – that even, transparent glow that sets things off so clearly – was color; nothing stormy, over-emphatic or disorderly here, but rather texture, immobility and density. Painting, in other words.

Out of the forms of inspiration that called for the attention of this man of whom we know virtually nothing – the Caravaggism of the Utrecht School, the lessons imported from Italy – we see the birth of a painter who in 12 short years would shape a new truth; an oeuvre as spellbinding in its studied and scrupulously reappraised technical mastery as in that indescribable magic made of calculated willpower and sheer poetry.

Did Vermeer live in a dream world? The recluse of Delft left no indications, no letters, nothing but a simple signature dated 1662 in the register of the St Luke's Guild. Plus the few words he had to say when, on 23 May 1672, he appeared as an expert before a notary in The Hague to give – he who had never set foot in Italy – his estimate of the worth of 12 paintings allegedly by Italian masters that were up for sale. And which, with his compatriot Joannes Jordaen, he declared to be fakes.

Do we know his face? André Malraux thought that several works show him at different periods of his life, but he can only be said, with some degree of certainty, to appear in *The Procuress*, now in Dresden: there we see him smiling ironically from beneath a broad beret – a musician, it seems, who has set aside his instrument for a glass of wine. Strangely this figure – is it really Vermeer himself? – is out of proportion to the others, as if standing outside this scene of debauchery in which, under the mercenary eye of a black-veiled madam, the customer fondles the girl's breast as he pays her. This clash of proportion comes from the painter's use of a mirror for the self-portrait; but perhaps, too, he is signaling an ironic detachment from what is taking place – even if it is an everyday part of the life in Holland. Nor is it anything like as shocking as the Dirck van Baburen painting of the same title, in which we see a bare-breasted girl swooning in the arms of her client.

There is, in fact, nothing surprising about Vermeer's borrowing from a painting whose licentiousness he toned down considerably: the Van Baburen work belonged to his mother-in-law, so he saw it regularly.

As in the interiors to come, this is not an assertive picture: the gestures, expressions and feelings are neither caricatured nor outrageous. There is no lesson in morality, either; just the mocking smile of an amused spectator in the top left corner.

This spectator is wearing a large, black velvet beret cheekily pushed back, and his clothes are those of a dandy of the time. Glass in hand, he toasts the lovers.

The Procuress

1656

oil on canvas, 143 x 130 cm,

Staatliche Kunstsammlungen, Alte Meister, Dresden.

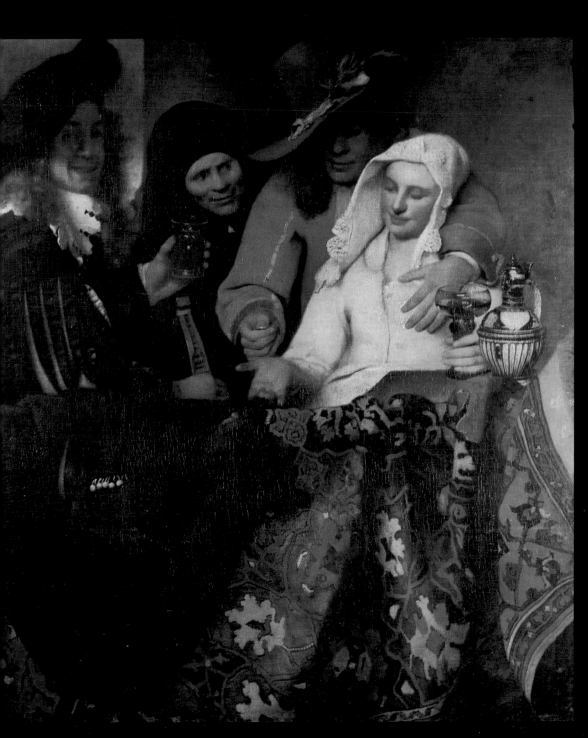

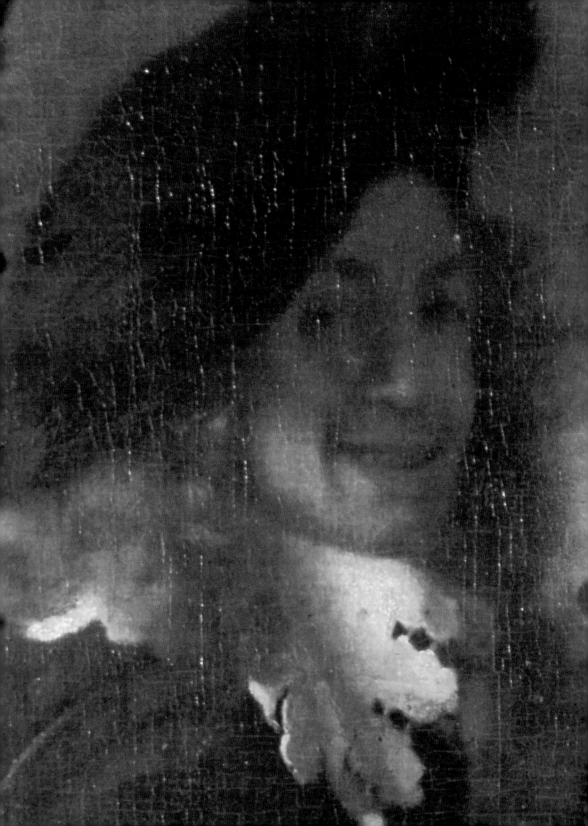

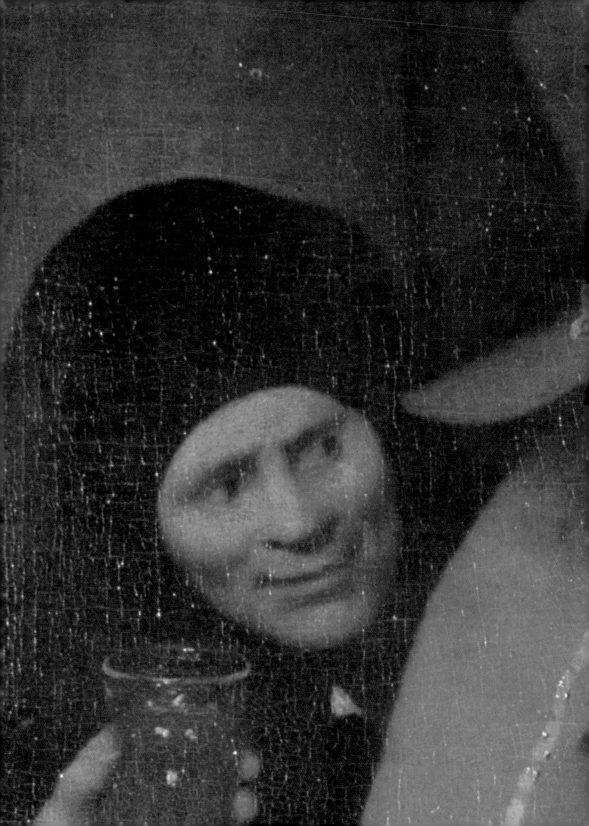

Dirck van Baburen (1595-1624)

The Procuress,

1622,

oil on canvas, 101.5 x 107.6 cm,

Isabella Stewart Gardner Museum, Boston, (stolen).

This free-spirited work belonged to Vermeer's mother in law, and Vermeer himself drew inspiration from it. From Utrecht, Van Baburen had mingled with the Caravaggists in Rome; his work is characterized by powerful gestures and facial expressions, and by a bold treatment of often trivial themes.

Vermeer was 24 and there is an easygoing gaiety about him that sits uneasily with his reputation as a taciturn figure doubly shut away in the reclusion of Delft and his art. He was a grave, physically frail man – he would die at 43 – and it was doubtless his health that made him melancholic and little given to communication.

No other painting presents the smile, the laughing eyes and the somewhat swaggering look of the musician in *The Procuress*. In *The Art of Painting*, executed ten years later and in which he is wearing almost the same clothes, Vermeer is seen from behind.

His known oeuvre opens with a hymn to woman, but one devoid of lyricism or sensuality. Dating from 1654, *Diana and Her Nymphs* or *The Toilet of Diana* was perhaps the work that earned him entry into the St Luke's Guild; and there is nothing surprising about the clear Italian inspiration in this work by a young painter influenced by the Utrecht School.

The scene is shot through with a Classical serenity. Diana, her forehead marked with the symbolic crescent moon, is seated on a rock amid her companions, some of whom are attentive while others are indifferent. One of them is kneeling and washing Diana's feet. The group is monumental in style, beautifully balanced and superbly colored: Diana's robes are golden and those of her companions are vivid red, yellow and blue, against a background of dark green trees. There is no restlessness about this picture: all is humility, seemliness and respect.

A near-religious
approach to life and art

This group of five women is similar to the one in the background of *Diana and her Companions* by Jacob van Loo, a painting Vermeer had seen in Amsterdam. Once again, there is nothing surprising about the resemblances and cross-fertilization we find in Dutch artistic centers, nor about the similarities of composition, the play of light and shade in the folds of the clothing: many currents were meeting and mingling here.

In Vermeer's case we cannot speak of direct influences, and it would be pointless to go looking for them in, for example, *Christ in the House of Martha and Mary*, a scene also painted by – among others – Erasmus II Quellinus and even Jan Steen. Yet it is true that his vision and technique are not yet fully formed and he does draw on other painters. The varied painting scene in Delft, Caravaggism, the Italian influences, the borrowings and imitations – all these played their part in initiating and showing Vermeer the way. Faced with several traditions, Joannes does not choose, he observes: his first canvases show him still hesitant about the direction to take and the style to

adopt. He readily draws on the Utrecht School, but this is because Italy seems to him to embody the innovative ferment every young painter is looking for. Yet he is too introverted to be swept away by artistic passion, he is contemplative, he deliberates and has a near-religious approach to life and art.

In these early works, then, nothing presages that mysterious geometry whose light caresses and highlights the contours of that "closed world" Proust spoke of, in which a painter dreams. *Diana and Her Nymphs* will be Vermeer's sole mythological work, as *Christ in the House of Martha and Mary* will be the sole Biblical one.

Like the other painters who used this latter subject, Vermeer drew his inspiration precisely from the passage in St Luke showing Martha "busy with her household tasks" while Mary "sat at Jesus' feet, and heard his word". Yet it is Mary, Jesus declares, who "hath chosen that good part, which shall not be taken away from her." In its alternating of warm and cool colors the composition achieves great sobriety, restricting itself to an unadorned dialog between the three protagonists. If we

recognise borrowings from other pictures of the period, as well as other similarities, these in no way detract from the scene's grandeur. Vermeer makes magnificent use of light to outline the near-life-size figures and sculpt the folds of their clothing; and the white splash of the tablecloth in the center draws all the pieces of the puzzle together.

Dating from 1656, *The Procuress* rounds off this early trilogy. I have already drawn attention to the odd presence of Joannes as musician, or of a musician taking the painter's place. As a point of transition between the historical works and the silent, meditative interiors, this scene has all the chromatic force and warmth of its predecessors. The dazzling canary yellow of the girl's bodice both contrasts with the scarlet doublet of her admirer and coincides with the most brightly lit part of the picture – which is also its subject: the money changing hands as the client caresses his partner's breast, farewelling her with an ultimate sign of affection or possession. In the foreground Vermeer has allowed himself the pleasure of adding an enormous Oriental carpet, all heavy, multicolored folds.

This more delicate and sensitive painting style, which followed the lusty, often trivial scenes and the "jubilant get-togethers" born of the Caravaggists' free naturalism, found Delft society more than welcoming to its new subjects. This was a reasonable city of wealthy puritan notables: prosperity is no spur to adventurousness and Vermeer's beginnings were

sober. Mainly, *Diana and Her Nymphs* and *Christ in the House of Martha and Mary* show him coming to terms with the recent artistic currents that interested him.

Some aspects of *The Procuress*, such as the Oriental carpet slipping from the table (Delft traded in carpets), certain everyday objects and the predominant red/yellow combination, are to be found in a canvas finished a year later – Joannes painted very slowly – whose spirit and composition are profoundly different from the earlier works: *A Maid Asleep*.

For the first time we see a Vermeer setting that uses a geometrical arrangement, but there is a hesitancy about the narrow view of this vestibule giving onto the more brightly lit room framed by the verticals. Has this servant girl really dozed off? The catalogue of the 1696 sale refers to "a drunken girl sleeping at a table", but there is no proof of this state. Before her lies a superb still life of a Delft dish and a white pitcher with a metal stopper. A series of clumsy restorations have removed the bottle and the glass of wine that might have explained that 1696 description.

On the wall, in the upper left corner, we see part of a painting *Cupid* that is also to be found in *Girl Interrupted in Her Music*, in New York and *A Young Woman Standing at a Virginal*, in the National Gallery in London. Here, however, this painting, attributed to Caesar van Everdingen, has a mask added to it. The presence of the mask in this first of Vermeer's "pictures within a picture" has generated several inter-

pretations: some have seen in it the sign of a disap-
pointment in love responsible not for a state of sleep
but one of nervous prostration. For Lawrence Gowing
the picture illustrates the moment when the immi-
nence of sleep lays bare our true feelings. Albert
Blankert, on the other hand, pays no attention to the
picture on the wall: "From the artistic point of view," he
says, "*A Maid Sleeping [A Maid Asleep]* is nothing more
than a try-out" and a version of that very ordinary sub-
ject of the time, the exhausted or idle servant girl
asleep in what could be an allegory of laziness.

But can we not also imagine a symbolic relationship
between the cupid and the dreaming young woman?

Beings swathed
in solitude

The three early canvases that have come down to us –
Diana and Her Nymphs, *Christ in the House of Martha
and Mary* and *The Procuress* – all have different themes.
But beginning with *A Maid Asleep*, the emphasis on com-
position is reinforced by a more concentrated aware-
ness of light, in a narrow context whose vertical and
horizontal lines herald the interiors to come.

What new impulses and desires is the painter react-
ing to? Is he out to immortalize dull but orderly domes-
tic settings with their gleaming furniture, the soft glow of
their everyday objects, their subdued lighting? These are
reflections of a new society, self-assured after surviv-
ing a period of war and religious strife, but from which
all exuberance and daring have been banished as
threats to hard-won order and security.

For this generation of 1630 that saw everything,
including love affairs, in terms of the measured gesture,
the furtive presence and the concealed feeling, the
lighting of rooms was that penumbra in which Thoré-
Burger, Vermeer's "discoverer", saw "pearl-colored

A Maid Asleep

c. 1657,
oil on canvas, 87.6 x 76.5 cm,
The Metropolitan Museum of Art, New York
(Bequest of Benjamin Altman, 1913).

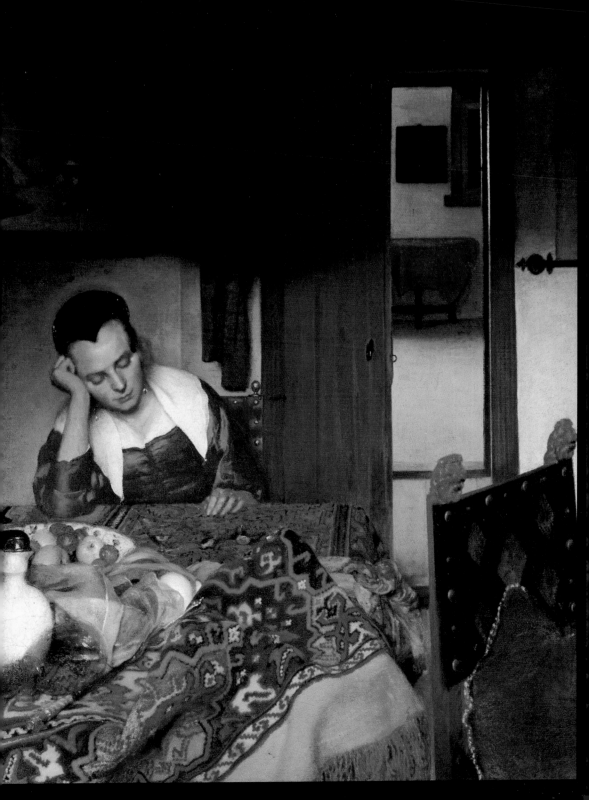

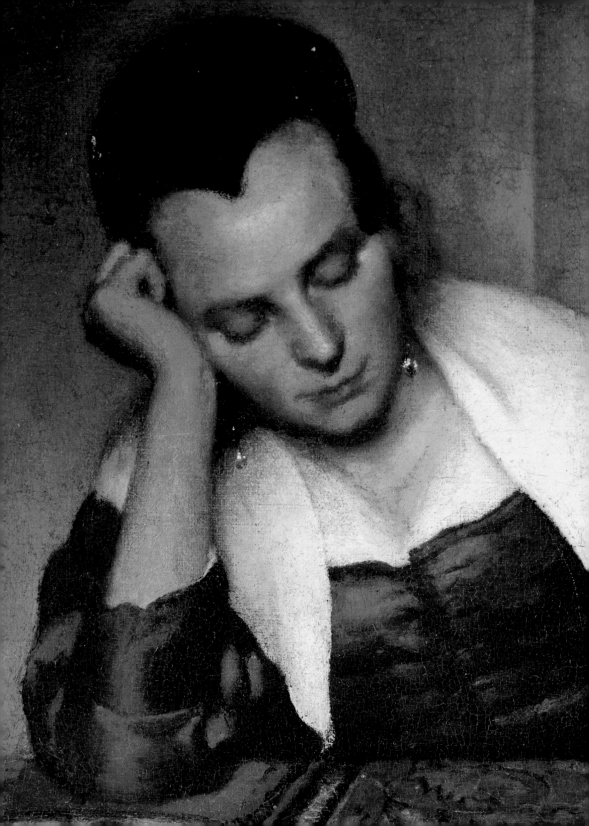

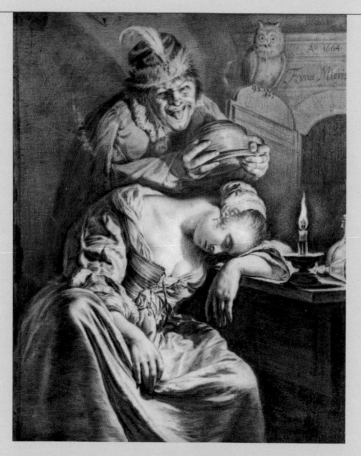

Frans van Mieris (1635-81)

The Sleeping Woman,
undated,
black chalk on parchment, 21.5 x 17.8 cm,
Château de Malmaison et de Bois-Préau,
Rueil-Malmaison.

shadows". No fiery noons, no triumphantly setting suns, but geometrical play, enchanting surprises, half-open doors, narrow corridors, discreet or unexpected views of the distance. The figures fit within the space as images of the fleeting moment: a conversation beginning or petering out; gently flowing music; a hand writing, embroidering, finishing its daily task, welcoming a suitor, unrolling a necklace, pouring milk or settling enigmatically on a globe of the world in a gesture of seeming possession.

These beings swathed in solitude seem unconcerned by the outside world, they live the moments of their lives as if they were the only people on earth. From one figure to another, as if caught in amber from the nearby sea, there emerges a small society in which each detail is light and color incorporated into the very fabric of things, giving objects their texture, their vibration, their reciprocal resonance. The French art historian Élie Faure insisted that Vermeer "had no imagination" – but what purpose would it have served? He paints what is, what he sees, and nothing comes between his vision of the little human comedy of a city, a caste, to which his entire life was linked. No one challenged him, no one attacked him, and everything seems to indicate that he was not only accepted but admired by his compatriots. That 1667 quatrain by Arnold Bon is clear evidence of local recognition.

Officer and Laughing Girl, *A Girl Reading a Letter by an Open Window*, *The Glass of Wine* and *The Milkmaid* are all probably from the period 1657-60. The subject matter is not exclusive to Vermeer – in 17th-century Dutch painting there are dozens of ladies reading letters, drinking wine in the company of the opposite sex, making music, performing household tasks or indulging in different pastimes. But Joannes takes these common-places and strips them of their conventionality, their picturesqueness and their triviality. In a meticulously scaled setting in which time flows by slowly, he has no qualms about re-using the same poses, the same motifs. He is not seeking originality at any price, nor even trying to be different, he simply recoils from innovation just as he does from the bizarre or the farcical.

Officer and Laughing Girl,

c. 1658,

oil on canvas, 50.5 x 46 cm,

Frick Collection, New York.

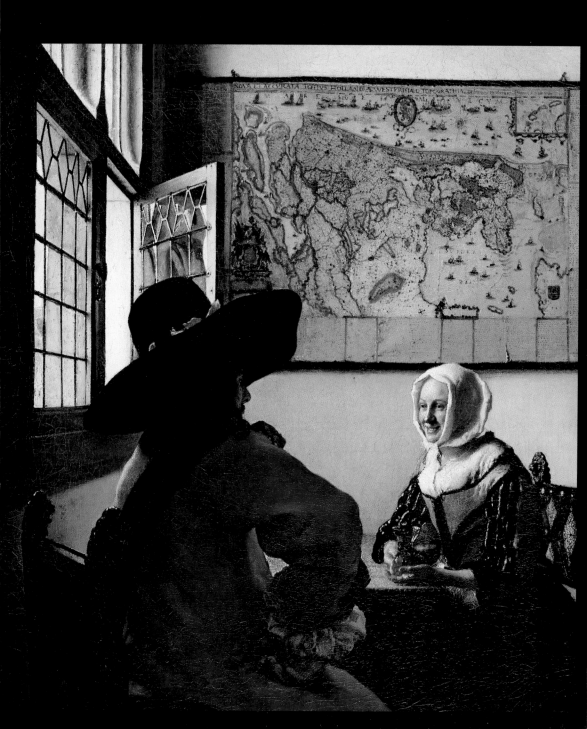

With Vermeer, no black. No daubing,
no trickery. Clarity everywhere, as much on the
back of an armchair, a table or a harpsichord
as over by the window. Except that each object
nuances its penumbra and mingles its tones with
the light around it. It is to this exactness of light
that Vermeer owes the harmony of his colors.
In his pictures, as in nature, ill-matching colors
— like yellow and blue, which he especially loves
— no longer clash. He can bring together tones
far removed from each other, passing from
the most tender minor key to great passion
and power. Vividness, vigor, finesse, variety,
the unexpected, the bizarre and something
indefinably rare and striking — he has all
the gifts of those bold colorists for whom light
is inexhaustibly magical.

Théophile Thoré, "Johannes Vermeer of Delft",
Gazette des Beaux-Arts, 1866.

Not the heroic but
the private

In Amsterdam the great Rembrandt van Rijn lived in glory. He had come there from Leiden, where he was born, in 1631 and in the following year – when Vermeer was born, he painted *The Anatomy Lesson*, his first success. This work marked the end of his period of influences and his engagement with the new artistic currents. At the crossroads of Mannerism and Caravaggism he opted briefly for the fashionable genres the portrait and the Biblical scene.

For his many pupils his studio would be an invaluable hive of industry as well as a launchpad. Rembrandt was rich, much loved and swimming in commissions; his palette lightened and became warmer, his brushstroke mellowed, his paint became steeped in light, incandescent. The portraits and the Biblical scenes were succeeded by historical works. And although not universally appreciated, *The Night Watch* (1642), a simple patrol transformed into a heroic act, was the high point of a dazzling – but poised to crumble – career.

In addition to the school of Rembrandt, Amsterdam was home to painters with other interests and inspirations; I have already mentioned their influence on the young Vermeer and his borrowings from them. What did he know, though, of the master he had probably never met? When Rembrandt's pupil Carel Fabritius moved to Delft in 1650 he made no secret of his urge to shake off the crushing weight of his teacher's genius and develop his own style in the peace and quiet of the provinces.

As we know, rumor turned poetry made Vermeer the pupil – and even more inaccurately – the rival of Fabritius, but it was significant that the two names should be associated. No great effort of the imagination was required to suppose that during the discussions the two – the elder and the beginner – must have had, the main topic would have been the great Rembrandt and his dramas of light and shade sublimated by a tormented, passionate soul.

Yet from the outset Vermeer went counter to him. His weapon was an atmosphere, that Delft interiorness made of transparency, softness, serenity, harmony of values and the absence of lyrical flights, effects of color or heady boldness of paint. Not the heroic, for Vermeer, but the private – the subtlety and depth of form and light.

This thrust towards pure unity, towards a pictorial order founded on strict harmony of straight line, plane and color, towards an almost scientific composition free of all ostentation and artifice – a pure work of the spirit – is unequivocal: Vermeer was Holland's first abstract painter.

The Milkmaid,
c. 1658-60
oil on canvas, 45.4 x 40.6 cm,
Rijksmuseum, Amsterdam.

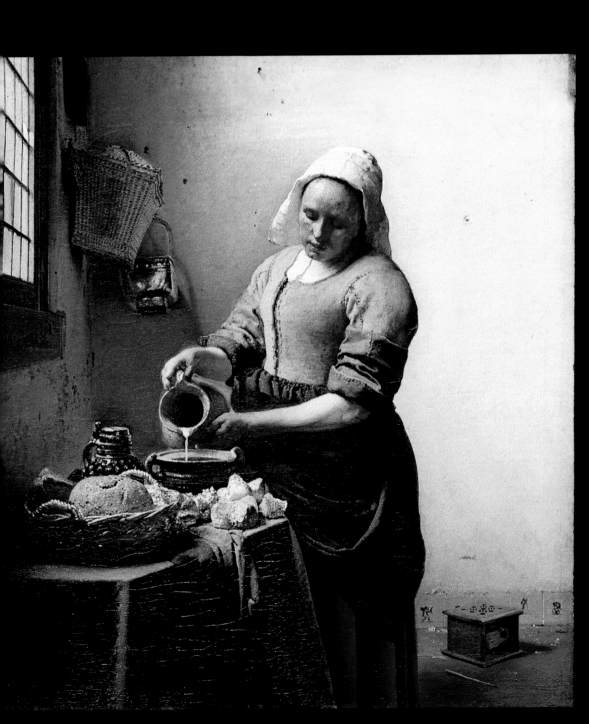

Organizing space around
a single figure

In *Officer and Laughing Girl* Vermeer pursues the study of geometrical interior space that was so much part of the Delft genre painters' desire to innovate. Among the most gifted of them, Peter de Hooch – in Delft from 1654 to 1662 before moving to Amsterdam – gained attention, and sometimes astonished, with subjects going beyond domestic or bourgeois trivia, and his specific use of light and atmosphere. Vermeer drew on this, playing with perspective in the cool clarity of enormous rooms whose ceiling-beams followed the perspective lines on the floor, and where half-open doors offered glimpses of other, sometimes mysterious, parts of the house.

A Maid Asleep had set Joannes on a new path: organization of space around a single figure. In *Officer and Laughing Girl* – where he uses backlighting for the first time – a good third of the composition is taken up by a soldier wearing a broad-brimmed black hat and red coat. He is seen from behind in three-quarter view, his hand on his hip, with the girl sitting across the table from him apparently amused by his probably flirtatious remarks.

The figures are out of proportion, the girl's frailness makes the soldier seem enormous which cre-

ates a curious contrast between foreground and midground, and the result, as so often with Vermeer, is a certain ambiguity. What is this overconfident, shadowy ruffian saying to the brightly lit girl, half-laughing, half-embarrassed, with her hands around the glass he has given her?

On the wall above her head is the large colored map of Holland and Western Frisia that we find, in whole or part, in several other Vermeer paintings. "A sign of knowledge," says critic Daniel Arasse. "In the 17th century the map signaled an impressive grasp of the figurative." But it was also a summons to reverie, emblematic of the city facing the sea. It is only in the work of Vermeer that this map, drawn up by Balthazar Florisz van Berckenrode around 1620, takes the form of a celebration of knowledge, as opposed to the mere "seeing" implied by the paintings on the walls in other pictures.

The figures in *The Glass of Wine* seem somewhat stiff, like actors adopting poses established in advance by the director. By contrast the *Girl Reading a Letter by an Open Window* is much more natural, in an interior that could hardly be simpler. In *The Glass of Wine* the setting, too, is fussy: everything — the seat, the table with its heavy carpet, the musical instruments, the picture on the wall — seem set there for all eternity and their texture is given precise attention.

The gentleman and the lady, "extras" from any number of Dutch paintings and plays, express no feeling in particular. What is supposed to have happened before or will happen afterwards does not concern them, and their behavior makes little or no suggestion of any romantic interest. In *Soldier and Laughing Girl* the glass of wine between the girl's hands is the focal point; in *The Glass of Wine* the plot is determined by the flask of wine on the table, as the woman lifts to her lips the wine poured for her by the attentive gentleman.

The girl hesitates to drink, her fingers approaching the glass as she smiles at the soldier's remarks; the woman, by contrast, drains her glass. Are the soldier and the gentleman, neither of whom is drinking, using alcohol as a means of seduction? Is this a game designed to test the partner's resistance? Or is merely theater, perhaps a rehearsal in which the characters are not yet at ease? This would explain the elusiveness of their behavior, the awkwardness of the poses, the illusory character of the emotions.

Vermeer paints not action but its imitation.

The Girl with a Glass of Wine
c. 1659-60,
oil on canvas, 77.5 x 66.7 cm,
Herzog Anton Ulrich-Museum, Brunswick.

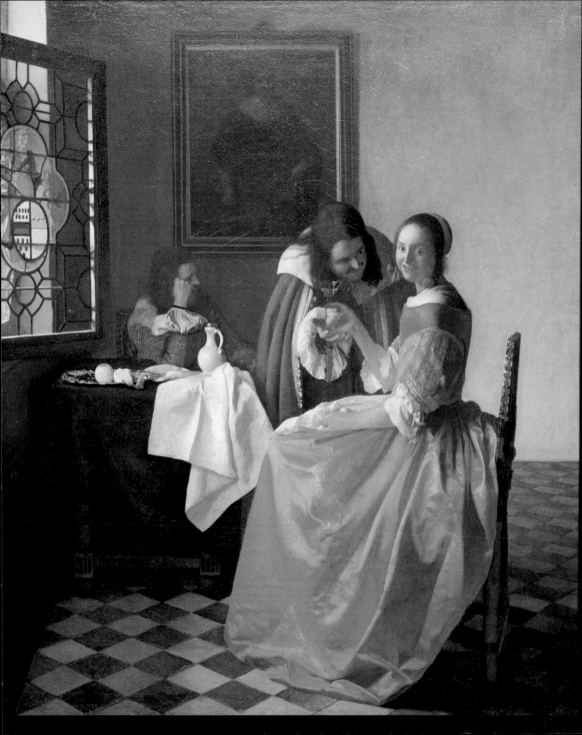

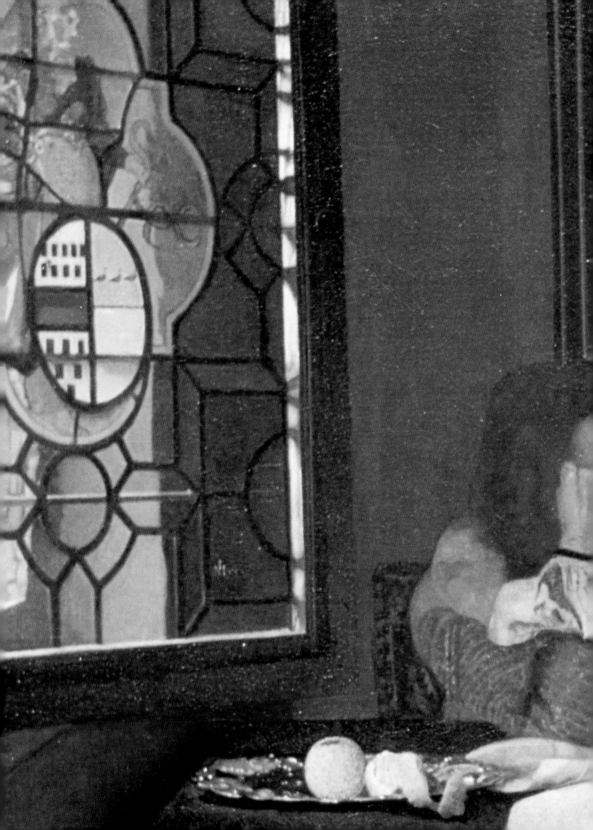

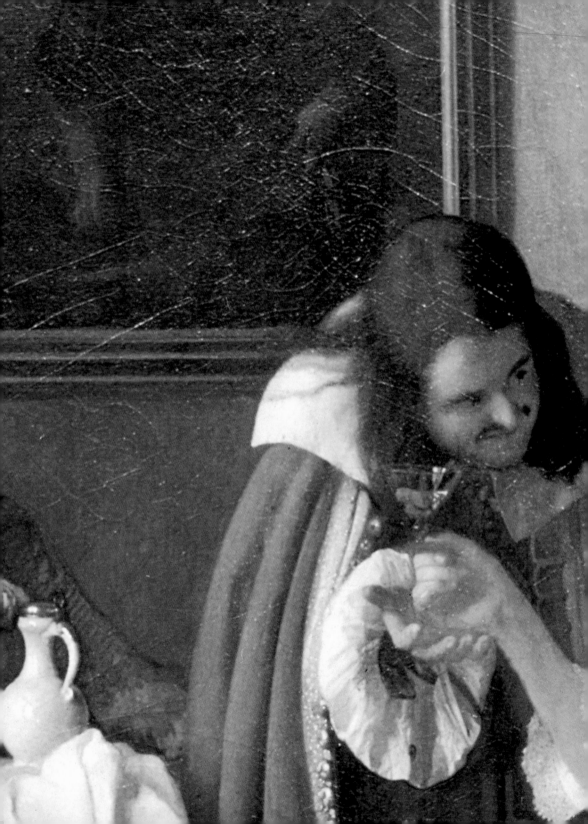

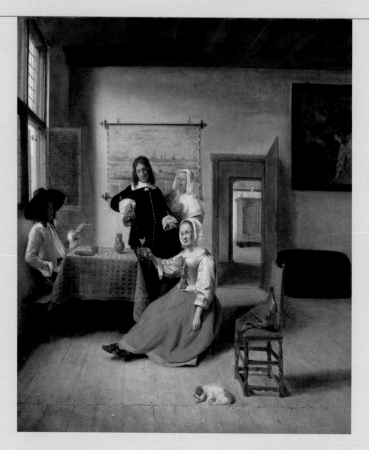

Pieter de Hooch (1629-84)

Woman Drinking with Soldiers,
1658,
oil on canvas, 69 x 60 cm,
Louvre, Paris.

Dutch artists had no misgivings about showing women drunk, whence the startling contrast here between the dignified males and the wild-eyed young woman raising her glass as she slumps in her splendid red dress. Vermeer never permitted himself this kind of scene and all he and de Hooch have in common are aspects of the composition: fleeing perspective, the map on the wall and the stained-glass window. De Hooch is joyous and sometimes vulgar, while for Vermeer the picture is all about painting, with line and color reflecting a rigorous logic. A good Catholic, he respects the opposite sex: a woman may drink in male company, but is never inebriated.

A plot suspended, uncertain, incomplete

The Girl with a Glass of Wine is, so to speak, an extension of the plot of *The Glass of Wine*, but the situation is clearer. The suitor is attentive, bending over the young woman and brushing against her fingers as he offers her a glass of wine; she, meanwhile, seated stiffly on her chair, turns towards the viewer as if asking how she should react. What should she do? Accept, and drink? Her look is both puzzled and crafty. Here we are witnessing a scene involving three people: has the third of them, sitting in the background behind a table or by a wine pitcher and what may be the leftovers of a drinking session, had his advances repulsed? Or – piqued or pensive, and with his head resting on his closed fist – is he simply awaiting his moment? In the stained-glass of the window Albert Blankert identifies what is "probably a symbol of temperance, a virtue these people tend to forget."

Once again Vermeer summons us to witness a scene of ambiguity and of hidden motives: the action is suspended, uncertain, incomplete. As in *The Glass of Wine*, the connection with the theater is obvious and the decor practically identical: a stained-glass window with a coat of arms, a still life on the table, a picture on the wall and a tiled floor.

The crucial object is the glass of wine. Dutch painting is rich both in drinking scenes and portrayals of drunkenness – we should not forget that Vermeer's father was a Delft innkeeper. The girl being addressed by the soldier and the one being so gallantly invited to drink by the gentlemen have both, as the painter knew from experience, good reason to be wary.

Vermeer a moralist? Why not?

Here he is still searching: the subject and the technique are still marked by those early influences. Nor is he always at ease with these groups of people – clumsiness and errors of proportion are visible, but the tonal contour is more delicate, the color sings and the relationship between the salmon-pink dress of the hesitant girl and the immaculate white of the serviette on the table is delicious. From one canvas to the next, ever alert to the need to break away from the conventions of genre painting, Vermeer intensifies or tones down, harmonizing his colors within the play of light. What is to be expected of him now?

A Girl Reading a Letter by an Open Window,
c. 1657-59,
oil on canvas, 83 x 64.5 cm,
Staatliche Kunstsammlungen, Gemäldegalerie, Dresden.

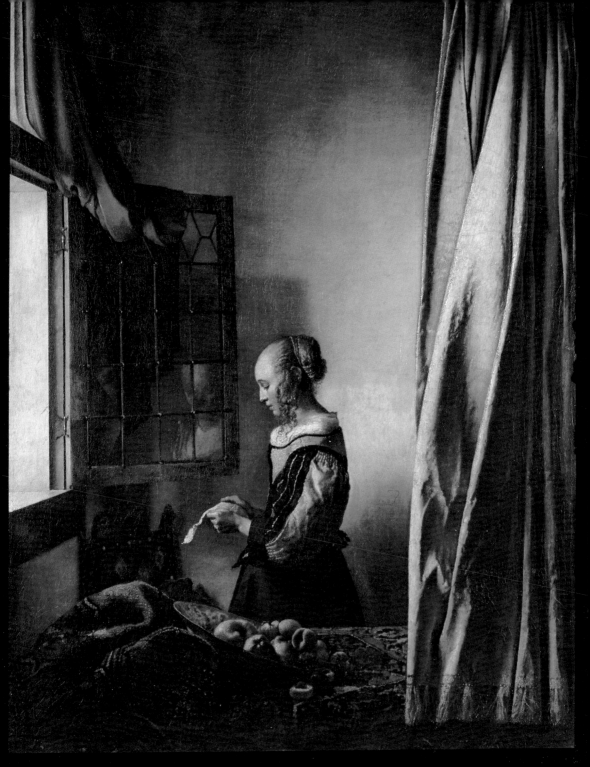

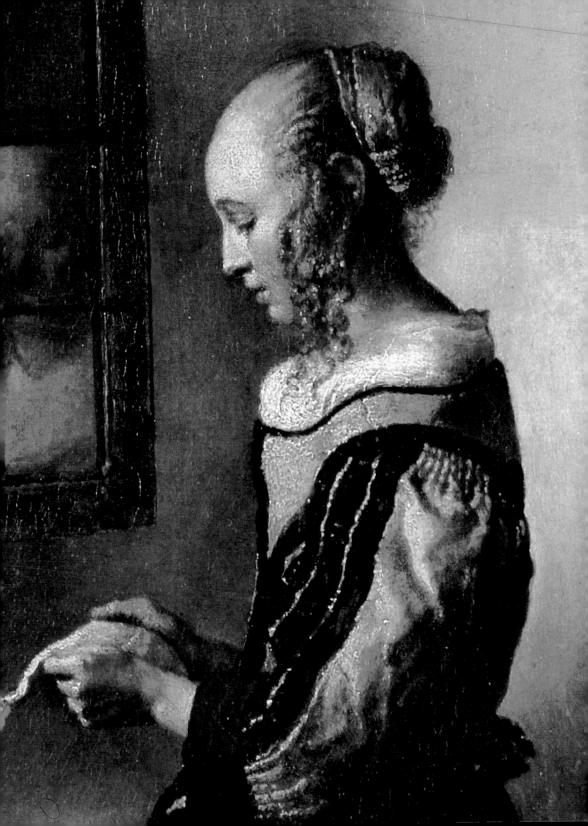

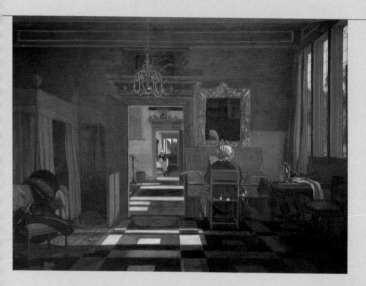

Facing: **Emanuel de Witte**

Interior with Woman Playing Harpsichord,
1665,

oil on canvas, 77.5 x 104.5 cm,

Museum Boymans-van Beuningen, Rotterdam.

De Witte's painting was not restricted to views of church interiors. In this typically Dutch dwelling with its receding perspectives and coolly subtle play of light on black-and-white tiles, he grants a very modest place indeed to the musician, who in the Vermeer version is the focus of the picture.

Facing: **Pieter de Hooch (1629-84)**

Woman Peeling Apples,
1663,

oil on canvas, 67.1 x 54.7 cm,

Wallace Collection, London.

A rival of Vermeer, de Hooch drew on the most ordinary aspects of daily life for visions in which restraint of gesture and facial expression suggest a ceremony made of simplicity and silence. Seventeenth-century Dutch painting took great pleasure in the truth, everyday humanity and the relaxed timeframe of such subjects.

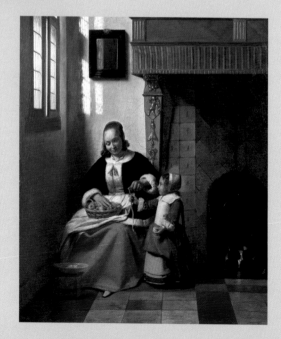

Austerely authentic
domestic ceremonial

Fabritius had doubtless put him on guard against too-violent contrasts, excessive impasto, the temptations of facile innovation and passionate expressiveness: true, he might find himself criticized for a lack of humanity, but in its place would be a calm, patient quest for truth.

In *A Girl Reading a Letter by an Open Window* Vermeer opts for a complex handling of light in which a single standing figure receives the brightness entering through an open window, over the pane hangs the red curtain, whose folds the painter studies in detail. He brings the same virtuosity to the heavy Oriental carpet covering the table and the bowl of apples and plums. To the right the vertical folds of a long golden curtain balance the geometrical character of the window frame.

A solidly built woman pouring milk into an earthenware container, *The Milkmaid* has a rusticity about her that contrasts with the bourgeois feel of the genre

paintings, as it does with the religious austerity of the girls reading or playing music. In place of their subtle harmony of muted blues, pale ochers and grays, the painter offers a creaminess of texture suggested by the nature of the subject: the stream of milk flowing from the jug, the rugged blue earthenware pot, the rough surface of the bread, and the blue of the cloth.

This is painting made
nourishment

The monumental treatment of the milkmaid is in marked contrast with the fragility of those girls drinking, reading letters or playing the virginal. Her generous curves are given a covering of strong colors: the wide white cap, the yellow bodice, the blue apron – and a similar harmony links the figure and the still life.

A banal subject, but one transformed into a solitary domestic ceremony of an austere and humble grandeur. There is a new truth here: more muted harmonies and sober, solid volumes. The light from the window on the left shapes the contours of those robust arms and broad hips against an area of gray wall from which a woven basket and a copper container are hanging. This plebeian simplicity will not recur in Vermeer's oeuvre.

The Glass of Wine,

1660-61,

oil on canvas, 66.3 x 76.5 cm,

Staatliche Museen, Gemäldegalerie, Berlin.

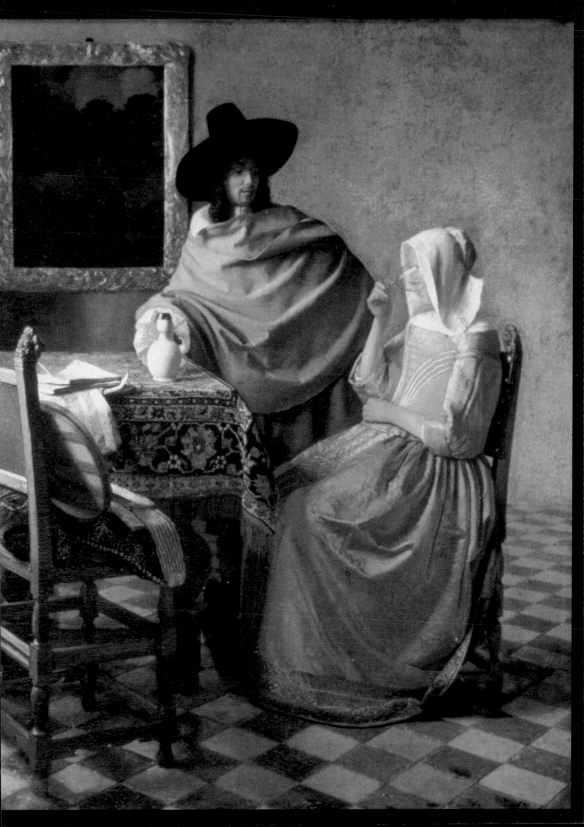

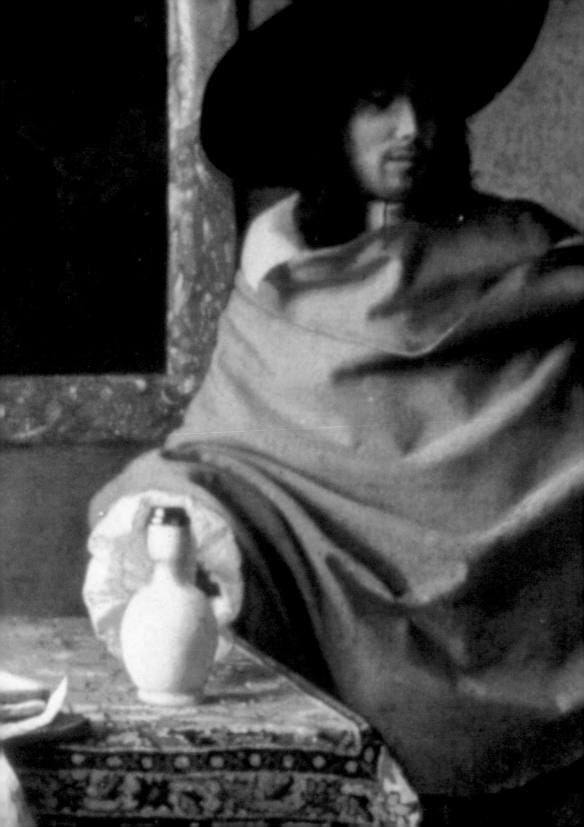

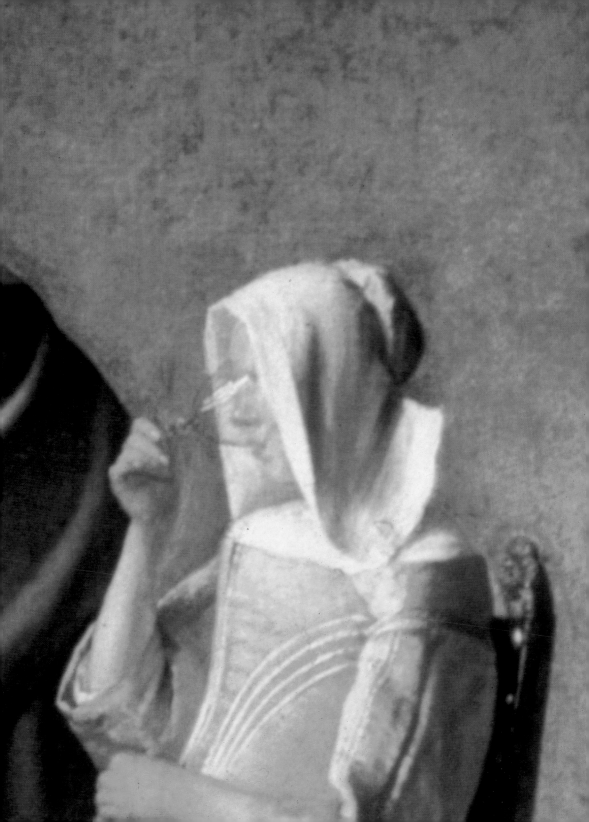

Peter de Hooch (1629-84)

The Cardplayers,
1670,
oil on canvas, 67 x 77 cm,
Louvre, Paris.

In the deep, changeless calm of a strictly geometrical interior, the painter brings together characters whose daily pastimes always have a slight solemnity about them. The keenness of observation does not, however, preclude a certain triviality; so de Hooch boosts the visual interest with elaborate "upper crust" costumes.

What Vermeer of Delft, the master of intimacy and the shared silence, reveals in his portraits and interiors, makes silence palpable without recourse to elaborate chiaroscuro; his touch is delicate and he attenuates the sense of solitude with the atmosphere of interiors we seem to know already.

E. M. Cioran, translation by Sanda Stolojan, l'Herne, coll. "Méandres", Paris, 1986.

An inspiring place for painters

The painters of Delft did not shut themselves away, however: daily life was out in the street as well, where the lime trees and red brick houses were reflected in the still waters of the canals. The urban panorama, spiked with the steeples and towers rising above a swelling ocean of roofs, inspired more than one painter to try out perspective effects that – sometimes, anyway – liberated their imaginations.

Looking at the landscapes that resulted, one has the impression of a city where all was peace and provincial calm. In fact this – Holland's third-largest city – was a very busy place whose horse-drawn passenger barges drew endless crowds of travelers bound for Rotterdam and The Hague. Begun in the late 16th century, the manufacture and trade in the famous Delft pottery contributed to the city's Europe-wide reputation as a business and trading crossroads.

Daniel Vosmaer, Hendrick Cornelis Vroom and Egbert van der Poel have left us panoramic views of the city. In 1652 Carel Fabritius had painted a very curious *View of Delft*, showing the late-15th-century Gothic Nieuwe Kerk,

the New Church, dominated by a brick and white stone tower next to the Baroque city hall, built in 1620. The perspective that serves as a backdrop to a seated figure in the left foreground is so odd that it has been described as observed through a concave lens.

Pieter de Hooch lived in Delft, and married there, in 1654-57. In his painting of its streets, alleyways and courtyard we see drinkers, servant girls, housewives and children all rubbing shoulders in an atmosphere of familiarity that is sometimes surprising. The master's skill is clearly visible in his use of perspective and the interplay of light and Vermeer would draw inspiration from these pictures, but without adopting de Hooch's practice of transposing interior scenes to outdoor settings. The nearest he comes to the de Hooch approach is *The Little Street* (Rijksmuseum, Amsterdam) an urban landscape typical of old Delft from which all reference to the world beyond has been eliminated.

Four very small, discreet presences – a woman sewing on the doorstep of her house; a servant kneeling to wash the sidewalk with the help of a boy, another

woman bending over a well in the alleyway – are no more than patches of color distributed over this sequence of architectural elements, of walls, doors, yards and passages set in contrast with a large red-brick townhouse with green shutters whose upper floor is soberly ornamented with stepped gables.

Is this a faithful rendering? A number of critics have set out to identify this group of houses, but without success – the neighborhood has changed considerably since then. Did Vermeer paint this picture looking out his window? What we recall most about it is the harmony of the reds, old rose and ocher, the "impressionistic" lightness of the technique and the damp limpidity of the cloudy sky.

Vermeer painted another *View of Houses in Delft*, mentioned at the time of the public sale in 1696, but all trace of it has been lost. Like the famous View of Delft, *The Little Street* dates from 1661.

Proust and the "little yellow wall"

This panoramic view of the city on the river Schie's path towards Rotterdam is the mythical Vermeer work; and even if the scene is no longer the same as in the 17th century, this view of Delft, with its air of near-unreality under the expanse of blue and gray sky, remains, for our eye and our mind, immutable. Here the motionless and the instantaneous fuse, as the surveyor and the poet come together in the light of a linear structure punctuated by the belfries and towers that shape its verticals of light and shade.

The city suggests an enormous vessel moving out to sea; such, René Huyghe assures us, was Vermeer's vision of it from the inn where he had set himself up to embrace this panorama. We can see this inn, Huyghe says, on an 18th-century engraving in the Delft city archives. The painter has opted for the early morning, when the streets are all but empty; and it was a May morning in 1921, at this same hour – when as a rule he went to bed – that Marcel Proust, despite his fatigue, chose to visit the Jeu de Paume gallery in Paris, and the exhibition of Dutch painting that had the city buzzing.

He had asked his friend Jean-Louis Vaudoyer to accompany him. As they set out Proust felt faint, but even so decided to continue on to the museum; barely able to stand, he leant on his friend's arm as he

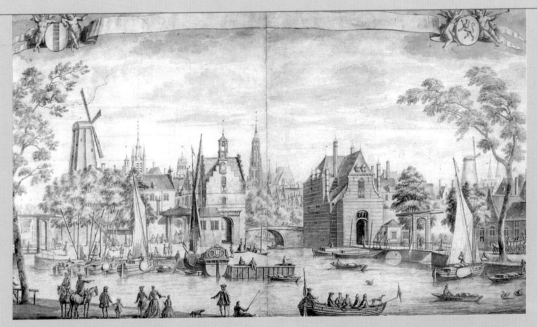

Abraham Rademaecker (1675-1735)

View of Delft with Schiedam and Rotterdam Gates,
drawing and wash, 66 x 106 cm,
Stedelijk Museum, Delft.

The Little Street,
c. 1657-58,
oil on canvas, 53.5 x 43.5 cm,
Rijksmuseum, Amsterdam.

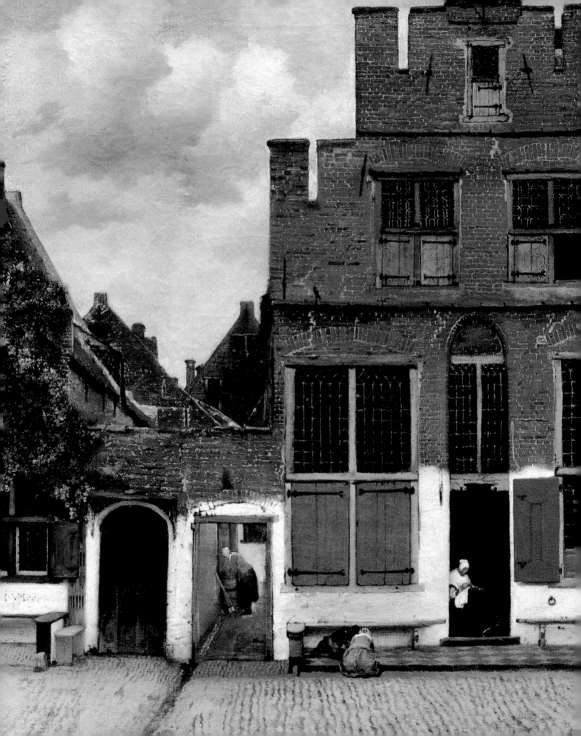

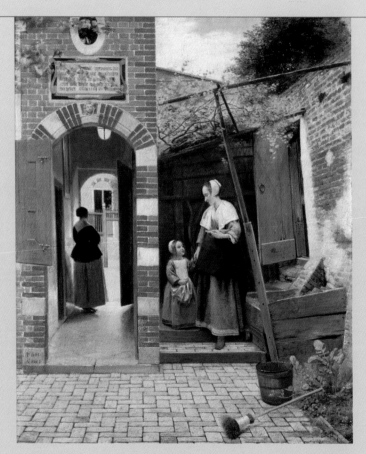

Pieter de Hooch (1629-84)

Courtyard of a House in Delft,
1658,
oil on canvas, 73.5 x 60 cm,
National Gallery, London.

Before leaving Delft in c. 1661, de Hooch painted the same group of houses as Vermeer, but — despite his skill — without the latter's spell-bindingly colorful poetry. Vermeer, said the Goncourt brothers, was "the only master to have turned local brick houses into a daguerreotype tinged with the spiritual..." In Dutch cities brick gradually replaced wood as a building material, bringing with it color effects that added to the formal variety of urban exteriors.

approached the view of Delft — a painting that had remained a dazzling memory since he had first seen it in the Mauritshuis during his stay in The Hague in 1902. Overwhelmed, he saw again the "little yellow wall" and suffered another attack of faintness; and it was the incidents of the morning and the emotion inspired by the painting that he would use to heighten the account he had already written of the death of the writer Bergotte in *The Prisoner*.

"He walked by several paintings and was struck by the aridity and pointlessness of an artistic artifice that was not worth the draftiness and sunlight of a palazzo in Venice or of some simple house by the sea. Then he was standing before the Vermeer, which he remembered as so much more vivid, so different than everything else he knew, but in which... he noticed for the first time the small figures in blue, noticed that the sand was pink, noticed the precious texture of the little yellow wall. His dizziness increasing, he fixed his gaze on the precious little wall like a child staring at a yellow butterfly he wants to capture... And he said over and over, Little yellow wall with a sloping roof, little yellow wall..." Abruptly seized by a fresh fainting fit, the ageing writer collapses onto the settee, then to the floor, and dies.

Vermeer literally constructed this *View of Delft* out of its colored elements, as if each patch of color, each plane had its place in the architecture, as in an Impressionist painting: the interplay of squares, triangles and diagonals, the alternation of warm and cool tones. In this early morning setting — 7 o'clock by the clock on the Schiedam gate — the atmosphere is one of moistness, mildness, expectation, as a handful of early birds chatter on the yellowish sand of the riverbank.

In a letter to his brother written in November 1885, Van Gogh speaks of having read the Goncourt brothers' book on Chardin and meditating at length on the painter's need not to be trapped by local tone: "I thought of Ver Meer's view of Delft in The Hague. When you look at it up close, it seems incredible, as if made with quite different colors from what you see from a few paces away."

What is unique in the View of Delft, as in 17th-century Dutch painting in general, is its mix of fluid brushwork, impasto and glazing, as if the painter had come back to his canvas several times, using different techniques. He mingles and contrasts the flat planes and glossy areas with little diamond-like dots, using fragments of light and areas of shadow side by side or sliding over each other as if interacting in the atmosphere, or reflecting the slow change in the light caused by the movement of the sun.

For Vermeer the *View of Delft* was an escape into open space, yet this space is as closed, as folded in on itself, as the interior scenes. Arthur K. Wheelock Jr sees in it "an exact visual transcription of an image provided by a camera obscura", a point of view backed up by the presence of preparatory sketch marks.

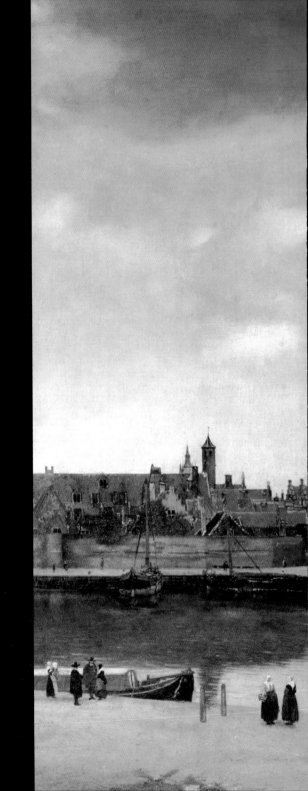

View of Delft,

c. 1660-61,

oil on canvas, 96.5 x 115.7 cm,

Mauritshuis, The Hague.

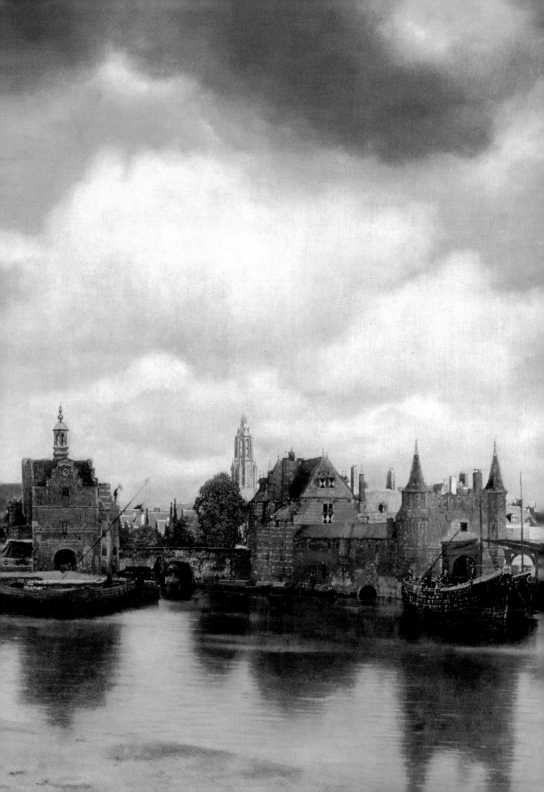

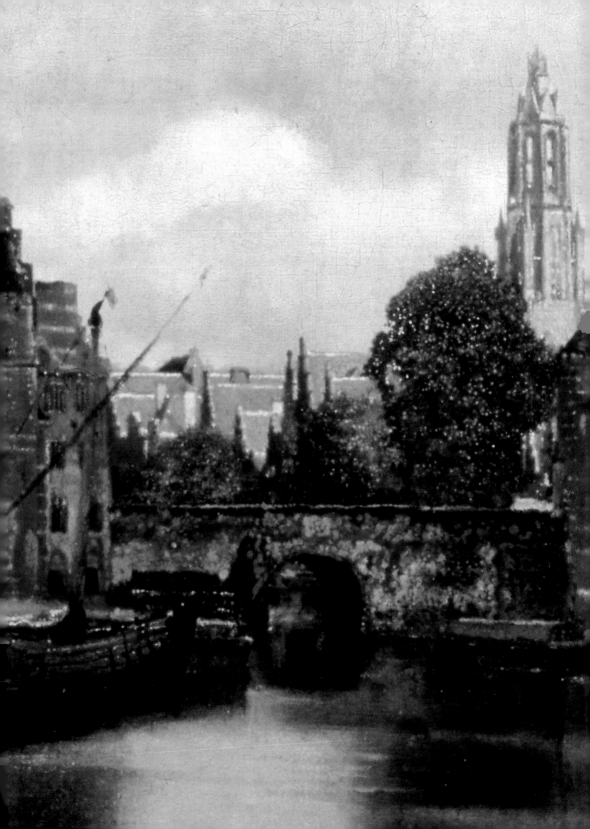

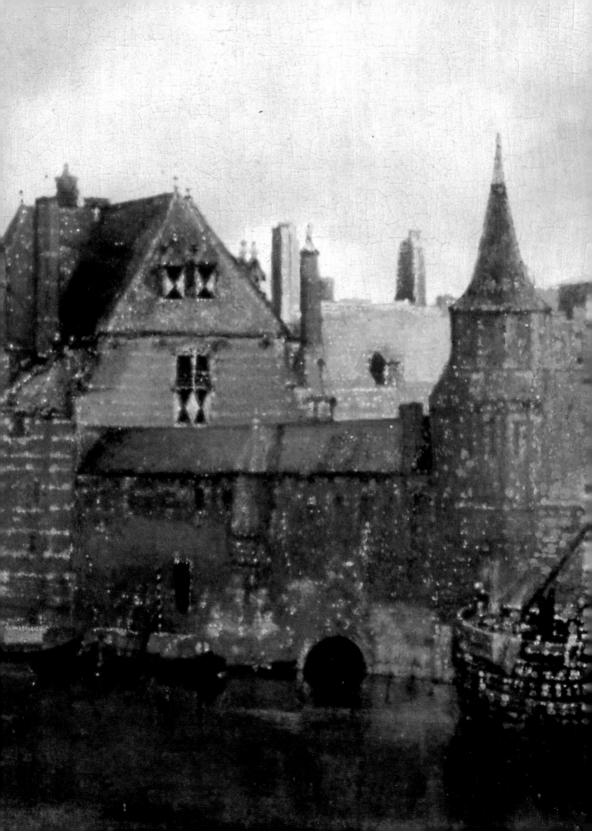

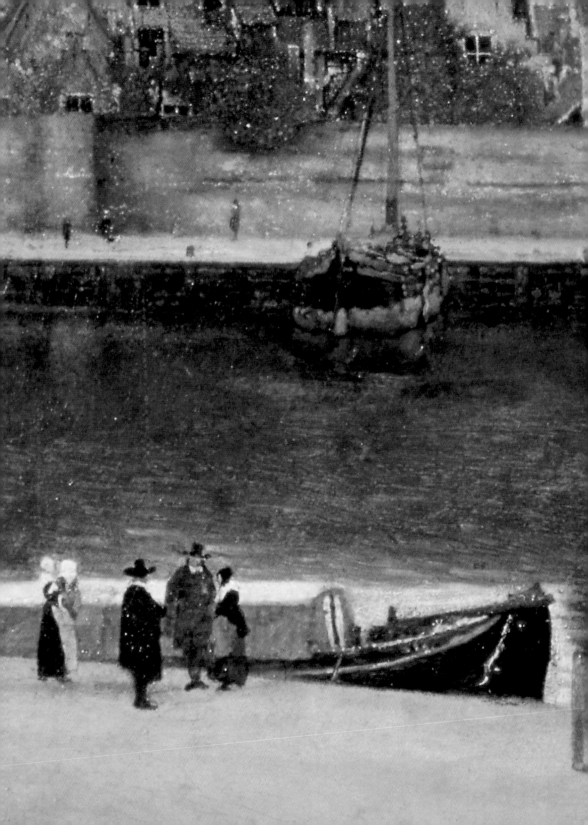

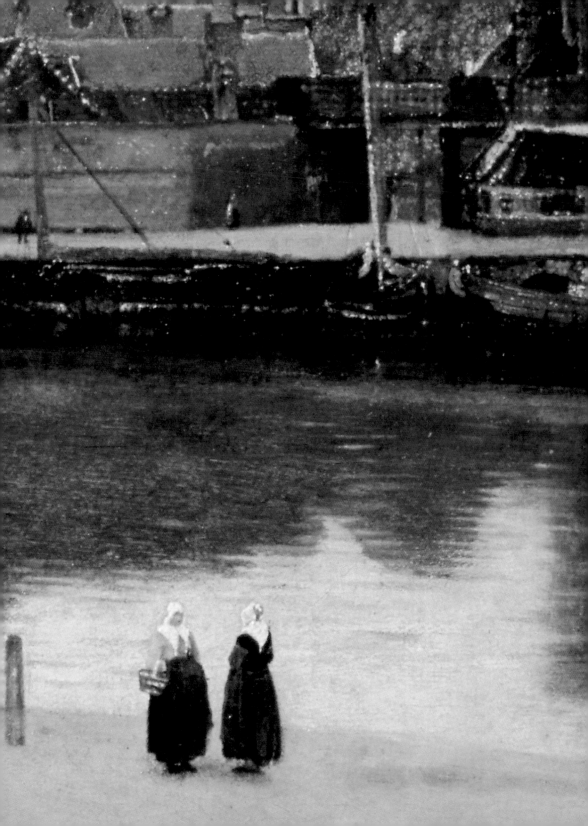

Carel Fabritius (1622-54)
View of Delft,
1652,
oil on canvas, 15.5 x 31.7 cm,
National Gallery, London.

This is old Delft seen from Oude Langen-dijk, where Vermeer lived. To the left of City Hall is the Nieuwe Kerk, or New Church. The distortion indicates that this picture was made using a peep-box.

Finally he came to the Vermeer, which he remembered as so much more vivid, so different than anything else he had ever seen, but in which, thanks to the article by the critic, he noticed for the first time the small figures in blue, noticed that the sand was pink, noticed the precious texture of the little yellow wall. His faintness increasing, he fixed his gaze on the precious little wall like a child staring at a yellow butterfly he wants in his hand. 'That is how

I should have written,' he said. 'My recent books are too terse, they needed layers of color to make the very prose precious, like that little yellow wall.' At the same time he could not ignore how faint he was feeling. In his mind's eye he saw a celestial scales, one pan bearing his own life, the other the little wall so beautifully executed in yellow. He felt that thoughtlessly he had sacrificed the former for the latter. 'Even so,' he said to himself, 'I would rather not become the highlight of the exhibition for the evening papers.'

Over and over he repeated to himself, 'Little yellow wall with a sloping roof, little yellow wall.' So saying, he collapsed onto a circular settee; and ceasing at once to consider his life in danger, he optimistically told himself, 'It's nothing, no more than a simple indigestion due to those undercooked potatoes.' When the shock struck again he fell from the settee to the floor, and the visitors and guards came running. He was dead.

Marcel Proust, In Search of Lost Time, *Gallimard, 1923.*

Strange "musical gatherings"

From 1660-62 onwards musical themes are a constant in Vermeer's oeuvre, with the characters taking their places in those bourgeois homes with their changeless decor. Showing no special concern with individuality, the painter responds to the taste of the time for the "musical gatherings" borrowed by the Utrecht School from the Italian followers of Caravaggio and adopted by many Dutch painters.

We know that Vermeer had first-hand acquaintance with the theater, and he turned these conventional, polite society get-togethers into psychological and moral comedies marked by his habitual allusive language. Musicologists tell us that chamber music facilitates intimate discussion, eye and hand contact, physical closeness and amorous declarations; and do not certain instruments suggest, by their very sonority, subtleties of sentiment that cannot always find expression in a socially correct context?

There is little or no action in Vermeer's musical subjects. The characters give no impression of taking action, rather it is intention, suggestion, innuendo that seem to underlie the sometimes incipient gestures, the furtive movements, the uneasy tensions of this small world of whose secret life the painter reveals a few brief moments.

Vermeer is a troubled psychologist and a troubling moralist.

In *Girl Interrupted in Her Music*, in the Frick Collection in New York, we find the same characters as in *The Glass of Wine* in Berlin and the *Girl with a Glass of Wine* in Brunswick. Not to mention the same objects or "props", and the same seats: on the wall the author has placed the symbolic Cupid, also known as Eros Triumphant, that appears in two other works.

What exactly is going on in *Girl Interrupted in Her Music*? A man strangely like the seducer of earlier canvases leans over a young girl turned towards the viewer in anxious surprise. He has placed the cittern on the table next to the pitcher of wine and seems keen to explain the score she is holding. Is he being over-

attentive? He has doubtless interrupted the duet to express his feelings to the young woman, but she fears that they will be discovered and is paying little attention to what her suitor has to say. This interruption gives Vermeer the opportunity to endow his characters with the immobility of his usual theatrical scenes.

In his variations on what Gowing calls the "intrusion gambit" – the seducer offering the girl wine or interrupting the music – Vermeer always opts for allusiveness. Is he drawing on a scene from Bredero's play *Lucelle*, in which, when Lucelle rejects the advances of a ridiculous baron, her confidante, using the pretext of a music lesson, brings in a young musician to distract and seduce her? Which he duly does.

In *The Music Lesson* and *The Concert,* chamber music also plays its part: this "music of solitude," as René Huyghe puts it, "in which a being expresses the solitude of his soul, or seeks an echo of it." And in which personal music, supplanting the large group performances of previous centuries, asserts its place in a society where a people with shared affinities meet in small, intimate gatherings.

Meditative and introverted, Vermeer was little drawn to the drinking bouts and licentiousness so many of his fellow artists were ready to portray this personality lent itself readily to that individuality of expression which in music as in poetry, the novel philosophy, prefigured – with the rising tide of freedom in human relations – an emotional and social turning point.

Here, perhaps, lies the explanation for the odd feeling of moving forward in time that Vermeer's oeuvre conveys. Forced by its Calvinist faith into a kind of permanent introspection, this cut-off, stay-at-home world summons man to discover his own reality and open himself to the new messages of painting.

In the musical paintings the behavior of the couples is linked to a shift in customs and lifestyle towards a more sophisticated sensibility – but a more secretive one too, with a symbolic language in which the woman's part is to keep the violent and the trivial at bay.

The Music Lesson is plotless. Having set his bass viola on the tiled floor at the end of the duet section, the man waits for his partner, standing at the keyboard, to finish playing. The inscription on the raised lid of the virginal is open to a host of interpretations. Translated it reads, "Music the companion of joy. The remedy for sorrow." A. P. de Mirimonde, that imaginative expert on Vermeer's musical subjects, sees here a scene of separation, but we know that while the painter's works have their own mystery and moral, their true meaning remains hidden.

It is worth lingering over this picture's remarkable geometrical handling of space, based on a network of verticals and obliques. Here Vermeer shows rare mastery of perspective and distribution of light in a room stopped off by the enormous rectangle of an end wall which dominates a juxtaposition of other, smaller rectangles. In the same way the orchestration of the var-

ious objects – the placing and the role of the majestic Oriental carpet in the foreground, the bass viola lying on the floor, the wine pitcher on the table, the chairback – is calculated to unsettle the eye while balancing out the verticals of the figures and the window.

The Concert shows three figures in a bourgeois interior. On the left a girl in a yellow silk dress is sitting at a harpsichord, seen from behind a seated man wearing a sword is playing a lute of which only the peg-box is visible; and standing on the right, a woman in a blue-green jacket trimmed with ermine is singing from a score and beating time. As is so often the case with Vermeer, this scene has generated all sorts of interpretative imaginings that ultimately seem to boil down to a simple story of a mother and daughter, or two sisters or friends accompanying their partner. However, on the wall behind the figure to the right is Van Baburen's painting *The Procuress*, which, as we know, hung in Vermeer's house and whose overtly libertine character insinuates that our three performers have intentions less pure than their apparent self-possession might indicate.

What exactly does the presence of this *Procuress* – side by side on the wall with a Ruysdaël-style landscape – suggest? We know Vermeer to be a master of the art of allusion, yet despite the countless exegeses his commentators have provided, we are no nearer a solution. Unless the scene is drawn from a play.

Girl Interrupted in Her Music,

c. 1660,

oil on canvas, 39.3 x 44.4 cm,

Frick Collection, New York.

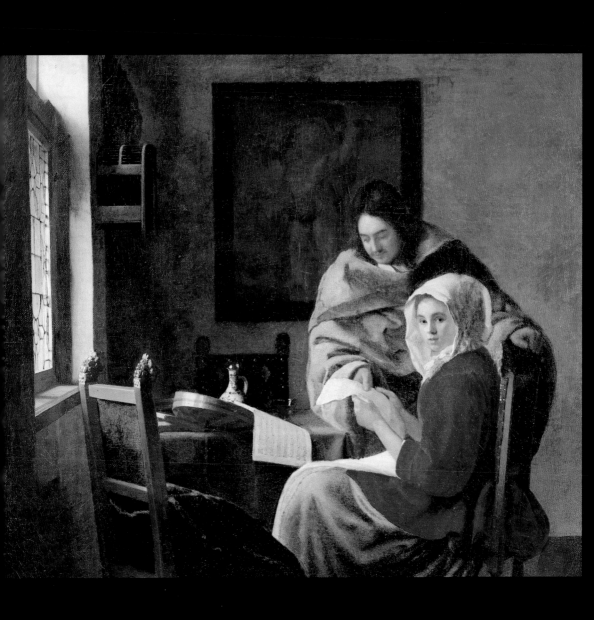

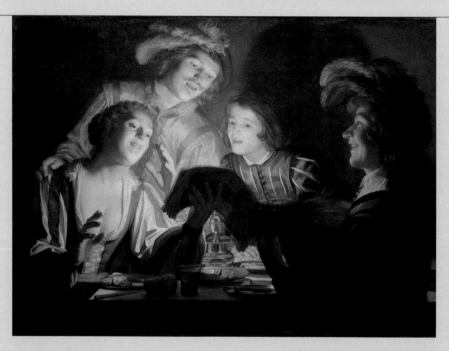

Gerard van Honthorst (1590-1656)

Musicians by Candlelight,

1623,

oil on canvas, 117 x 146 cm,

Statens Museum for Kunst, Copenhagen.

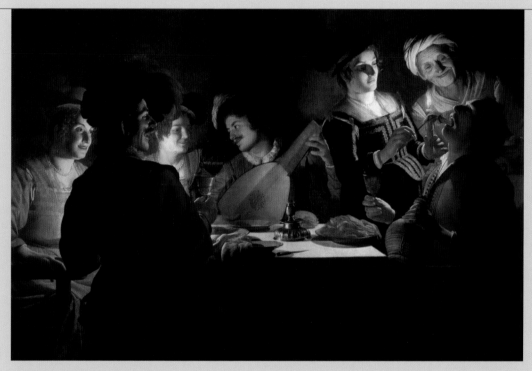

Gerrit van Honthorst (1590–1656)

Galant Evening Meal (with Lute Player),
1617,
oil on canvas, 144 x 122 cm,
Galleria degli Uffizi, Florence.

Together with Hendrik ter Brugghen and Van Baburen, Honthorst was one of the driving forces behind Caravaggism in his home town of Utrecht and in Northern Holland. As in the *Galant Evening Meal (with Lute Player),* he here combines the contrasts provided by candlelight with Caravaggio's popular realism and expressive foreshortening. Honthorst can also claim credit for bringing to Holland the grand decorative manner of the Carracci family, tempering its excesses with a spontaneous humor which in his last genre scenes — he died in Amsterdam in 1656 — set him apart from Caravaggism.

The Music Lesson,
c. 1662-64,
oil on canvas, 74 x 64.5 cm,
The Royal Collection, London.

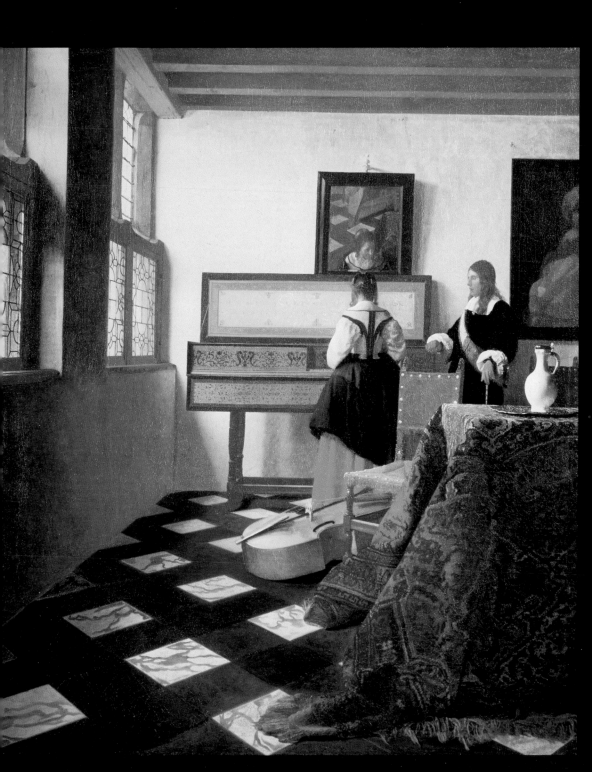

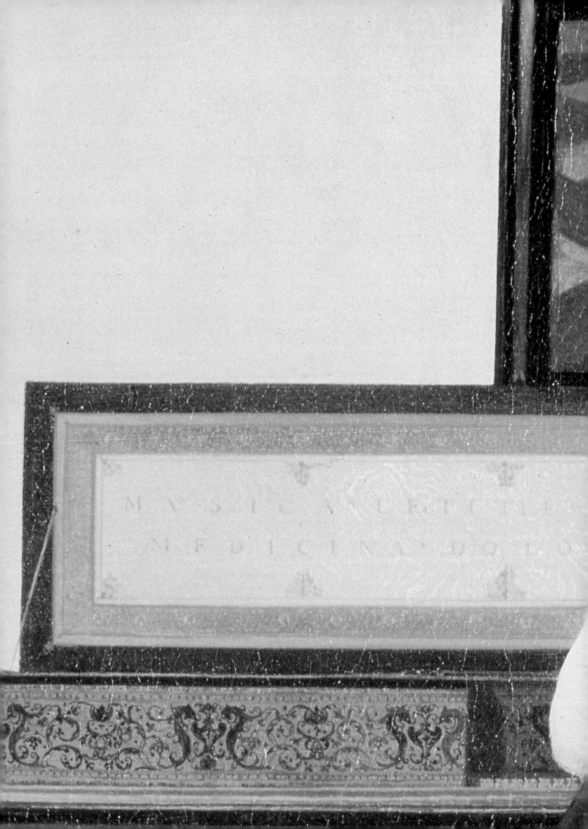

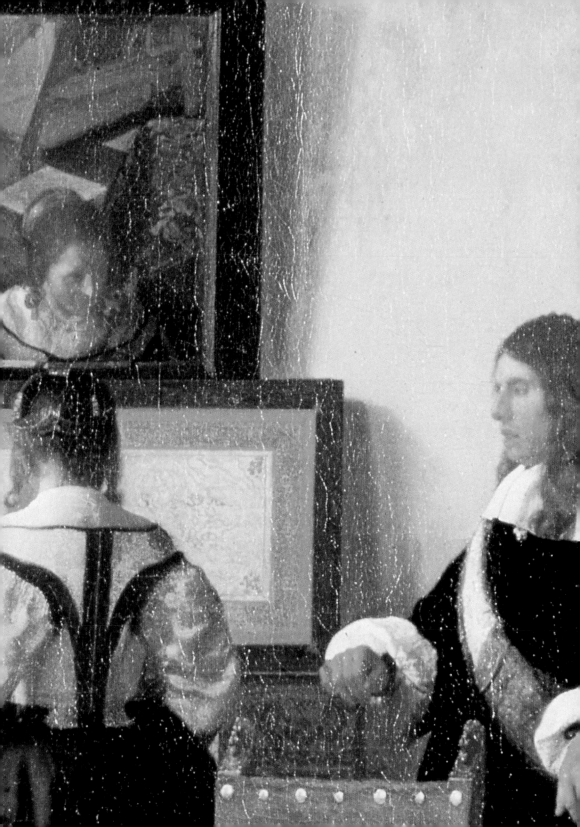

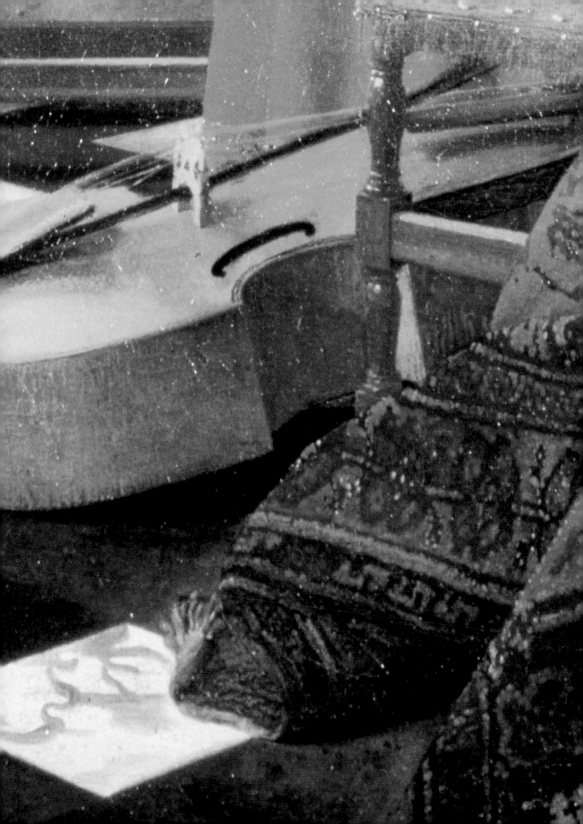

The Concert,

c. 1664-66.

oil on canvas, 69 x 63 cm,

Isabella Stewart Gardner Museum, Boston (stolen).

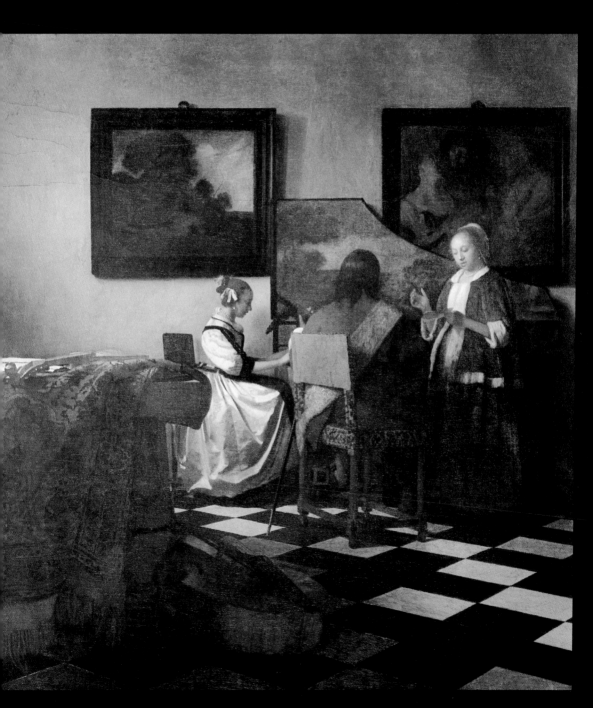

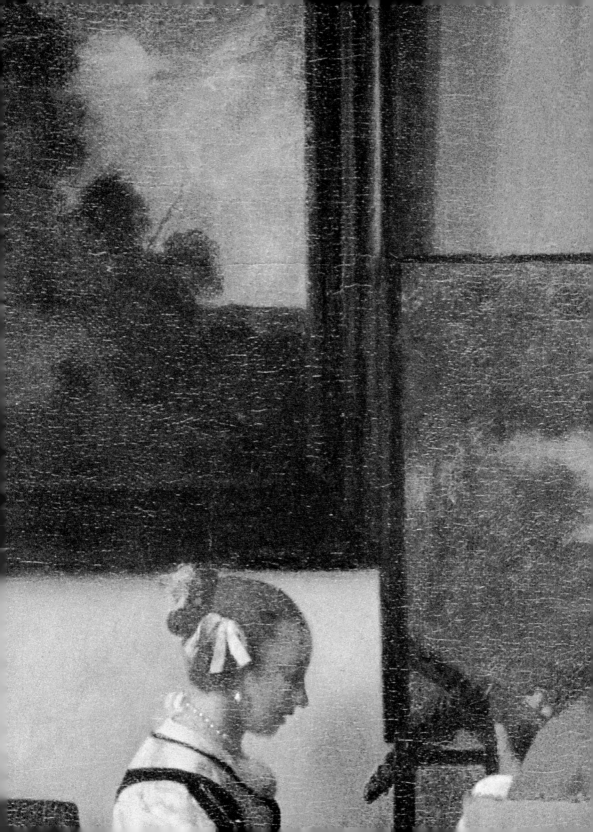

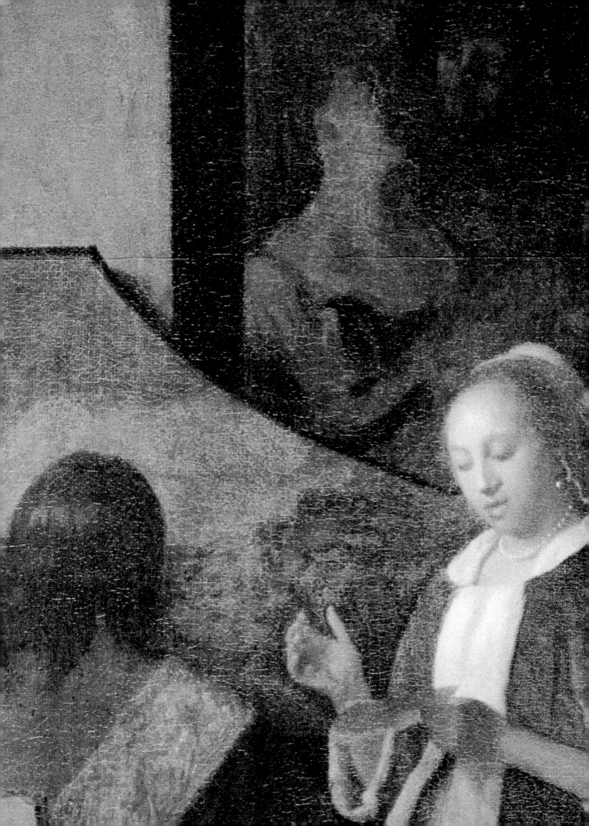

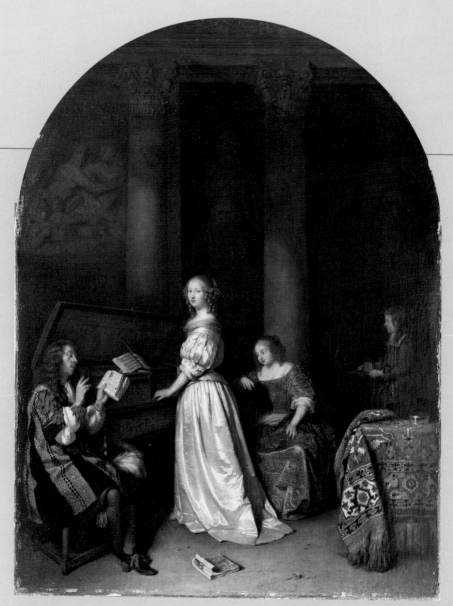

Caspar Netscher (1639-84)

Woman at the Piano,
1670,
oil on canvas,
Gemäldegalerie, Alte Meister, Dresden.

Gerrit ter Borch (1617-81)
Duet: Singer and Theorbo Player,
c. 1660,
oil on canvas, 82.5 x 72 cm,
Louvre, Paris.

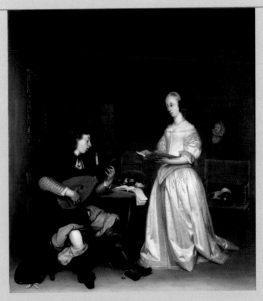

Gabriel Metsu (1629-67)
The Music Lesson,
17th century,
oil on wood, 32 x 24.5 cm,
Louvre, Paris.

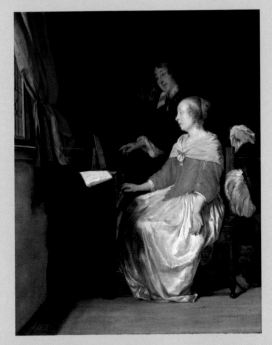

While the styles and intentions might differ between the portrait and the genre scene, the theme is common to these contemporaries of Vermeer: the practice of music in elegant social circles. Over the preceding 30 years or so instruments had evolved: the difficult fingering required by the lute and its relatives, the theorbo and the archlute, saw them supplanted by the harpsichord, virginal and spinet. A consequence was increased use of the bass viol, whose sweet, shimmering, unobtrusive tone provided a perfect accompaniment to the crystalline sounds of the harpsichord. The guitar enjoyed a rise in popularity, as did the cittern and the mandola, with its oval body and stubby neck. Vermeer and the 17th-century Dutch painters often showed these instruments in the context of small, intimate performances.

The Guitar Player,

c. 1671–72,

oil on canvas, 53 x 46.3 cm,

The Iveagh Bequest, Kenwood House, London.

A Lady Seated at a Virginal,
1670,
oil on canvas, 51.5 x 45.5 cm,
National Gallery, London.

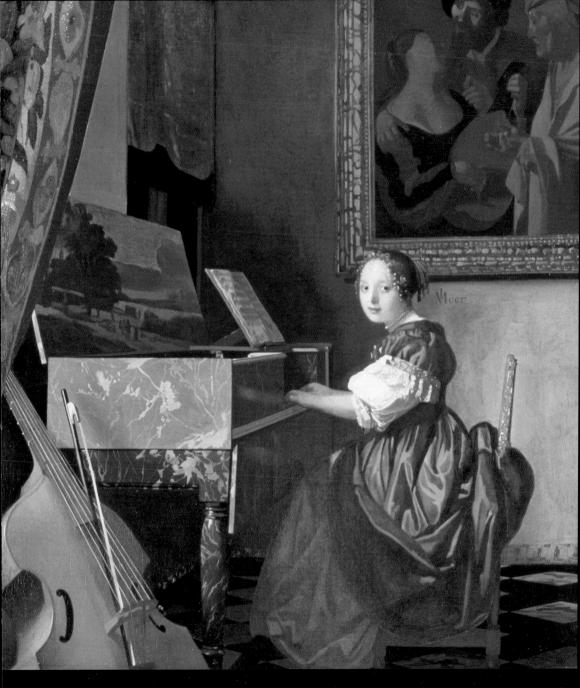

That mysterious
girl with a pearl earring

Vermeer's women belong to his own limited, movingly simple world. Not wealthy and having no powerful patrons, the painter had to get his family – his wife and daughters – to pose for him. Even so, with one exception for which the model is unknown, none of his pictures is a portrait: he kept his distance from those women who, like him, oscillate between dream and reality and do not yield up their mystery. His women share his withdrawal, his mediocre life and his silence, but without straying from the lifestyles of their period; made in their image, Vermeer's art is free of ostentation, the picturesque and – despite the sometimes extreme imaginings of zealous commentators – juicy trivia. The same aura of silent concentration surrounds the women reading a book or a letter, writing, embroidering or doing lacework. It immobilizes them in a space in their image, on their scale, and in a near-eternal time-frame in which they are immersed body and soul.

How can we pull our gaze away from the anxious, curious eyes of *The Girl with a Pearl Earring*, one of the most moving of his paintings? Her graceful features have the velvety freshness of a Chardin peach and part of her tightly wound blue and yellow turban falls in a skilfully rendered vertical fold to her shoulders. She is wearing a large pearl earring. And the setting is a sober as you can get: a dark monochrome backdrop.

What is there about her charm we find so troubling? The soft-focus effect of the face with its total lack of artifice and the smoothness of that delicately blurred form – Daniel Arasse speaks of the sfumato whose principle was established by Leonardo da Vinci – have an undeniable appeal that combines naturalness with a dreamy quality. *The Girl with a Pearl Earring* is not made of flesh, does not awaken desire, she is simply presence, purity and mystery.

The face of *Study of a Young Woman*, painted some years later, is more expressive: her features lack grace, her eyes are too far apart, the mouth is wide and thin-lipped, the forehead high and on her head is a long, dark-pink veil falling in what have been called Classical folds. The face is so frankly individual that it has been considered by some as a commissioned portrait, in which case it would be Vermeer's only one. Yet in Holland, the portrait was a major source of income for painters without religious commissions, and an excellent way of making oneself known.

Gerrit Dou (1613-75),

The Lacemaker,

1667,

oil on canvas, 30.5 x 25.5 cm,

Staatliche Kunsthalle, Berlin.

The lacemaker is a typical figure of 17ᵗʰ-century Dutch cottage industry. Several painters used the subject, here presented by Gerrit Dou, as a kind of theatre scene. In the foreground is a still life that includes a book — a simple distraction for the young woman, or a technical work to do with her trade? Vermeer's lacemaker, by contrast, is totally absorbed in her task, concentrating patiently on her bobbins. For the master of Delft this is the very image of humble, honest work: silence, solitude and pure poetry free from all triviality and affectation.

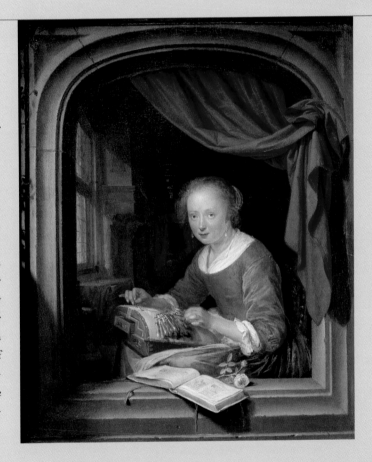

The Girl with a Pearl Earring,
c. 1665-66,
oil on canvas, 44.5 x 39 cm,
Mauritshuis, The Hague.

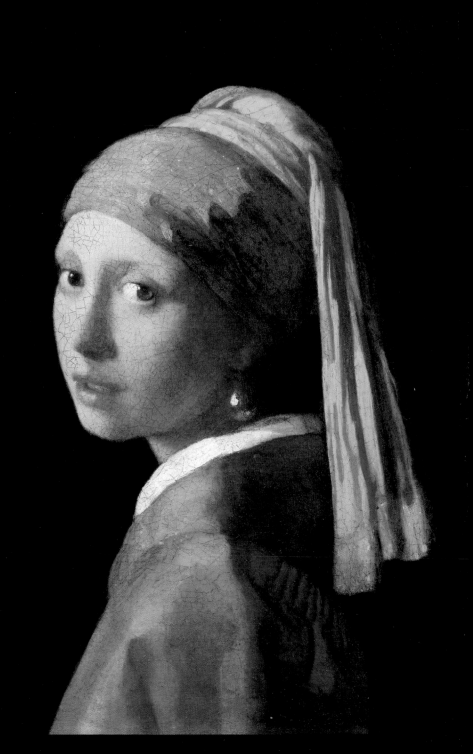

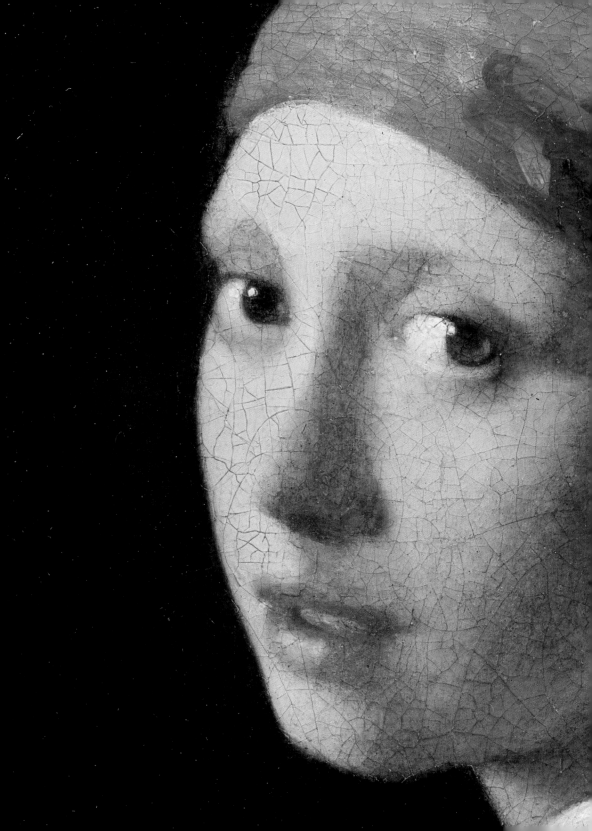

Study of a Young Woman,
c. 1666–67,
oil on canvas, 45 x 40 cm,
The Metropolitan Museum of Art, New York.

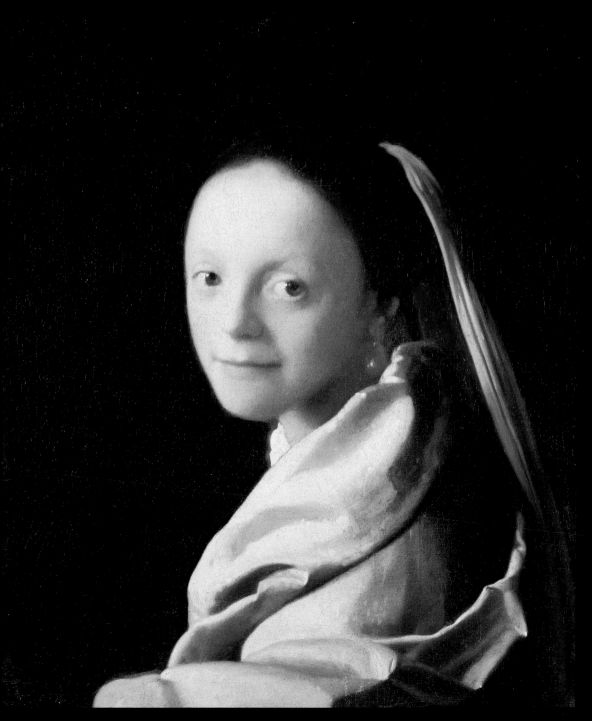

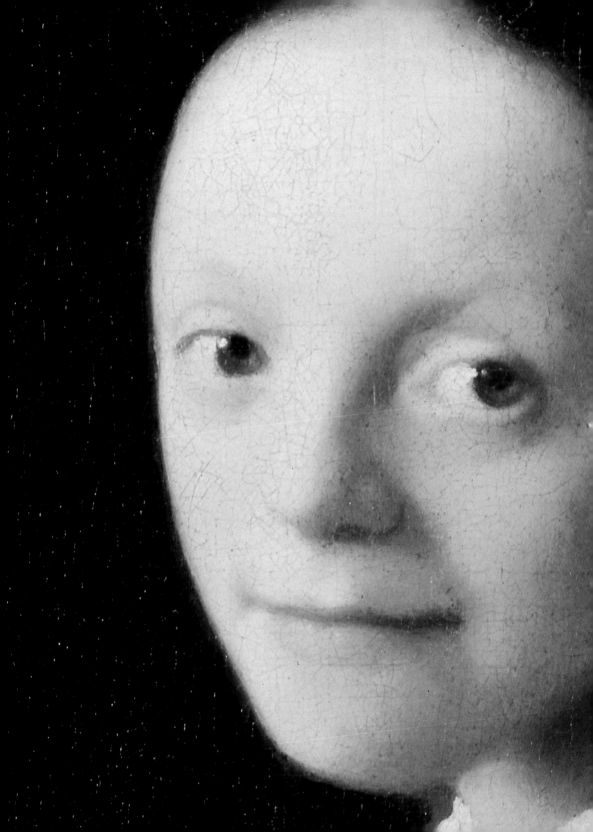

6

Family problems and income

There is something odd about Montconys' reaction after his visit to Vermeer in 1663. After all, he saw no pictures in the studio and little more when he went to see Mieris (a single, finished canvas) and Gerrit Dou (an unfinished work). On 18 October the painter was elected dean of the Guild, but why did he have no pictures to show? Opinions vary – either he had no commissions or he had sold everything. Now Vermeer was not prolific – he painted two or three pictures a year – and with Montconys having seen one in a bakery it was assumed that this was how he paid for his bread. Yet in 17th-century Holland a baker – or any other shopkeeper for that matter – could easily have paintings in his shop since they were on sale at fairs and village fêtes.

The year 1663 was particularly trying for Vermeer. His brother-in-law Willem Bolnes had borrowed money from his mother Maria Thins and on discovering the rate of interest, erupted in anger and called Vermeer an "old Papist bastard". Knife in hand he threatened the painter and his wife Catherina so energetically that it was considered necessary to commit him to a home for "delinquents and mental defectives".

Nothing is known of how Vermeer handled this difficult situation which lasted two years – 1663-65 – during which he painted some of his most important pictures. In May 1667 his mother-in-law officially authorized him to recover various outstanding debts, including that of Willem Bolnes; and on 25 September she drew up a will leaving five-sixths of her estate to her daughter and the remainder to the still-interned Willem. Thus the Vermeers were not without money and it would seem that it was thanks to his mother-in-law, in whose house they lived, that he could continue to work while selling very little.

Young Woman with a Water Pitcher,

c. 1664-65,

oil on canvas, 45.7 x 40.6 cm,

The Metropolitan Museum of Art, New York.

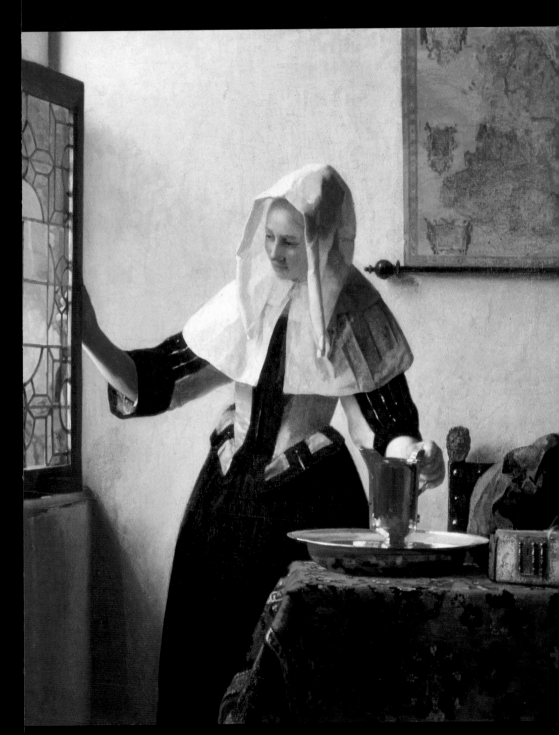

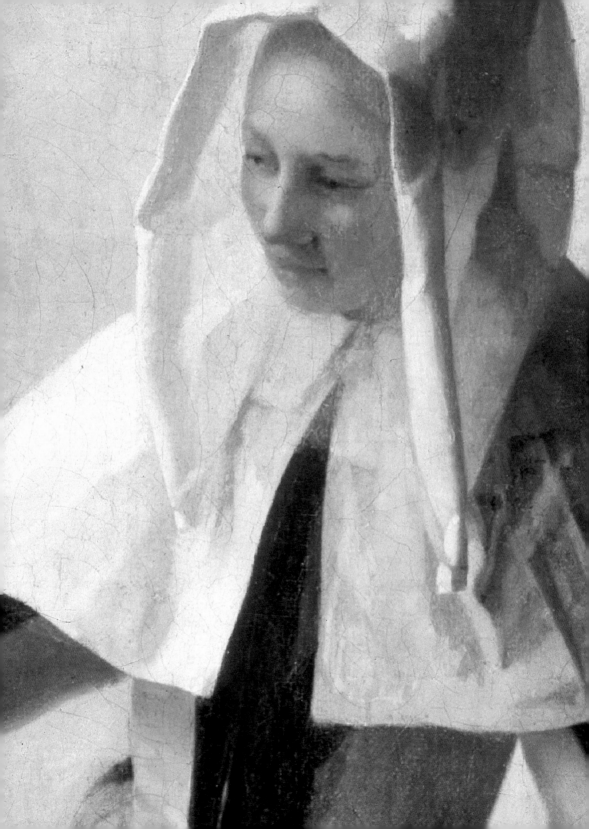

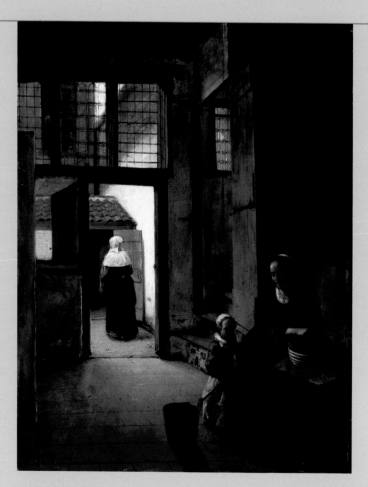

Pieter de Hooch (1629-84)

Courtyard of a Dutch House,
undated,
oil on wood, 60 x 49 cm,
Louvre, Paris.

Here the painter plays masterfully play with a series of geometrical planes and figures from everyday life. De Hooch had come to live in Delft in 1655 and lived there until c. 1661, getting to know Fabritius and Vermeer, who was three years his junior. He brought a subtle palette to his many domestic scenes and interiors, using light and atmosphere with a skill that compensated for the slightness of his subject matter.

Jacobus Vrel (active 1654–62)

Woman at a Window,

1654,

oil on canvas, 66 x 47.5 cm

Kunsthistorisches Museum, Vienna.

The lady of the house, it was said at the time in Holland, spent six hours a day on her doorstep or at the window. Here the window's geometry is ornamented with monumental panes allowing the light to enter from outside. The figure is no more than a small part of the delicate interplay of light and shade that is the true subject of this painting, which has a mysterious poetry and naive charm all its own.

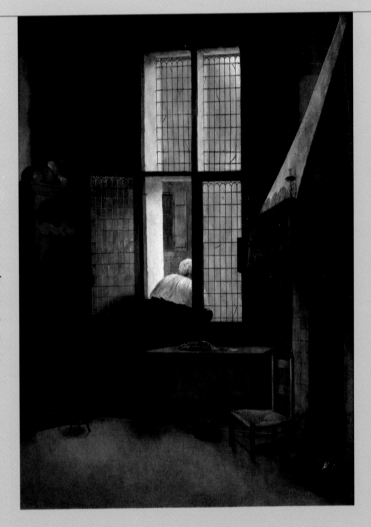

Do you know a painter called Vermeer?
He has painted a beautiful,
very distinguished pregnant
Dutch lady. The palette used by this
strange painter is blue, lemon yellow,
pearl gray, black and white. True, his
few works may show all the richness of
a full palette, but his use of lemon
yellow, pale blue and pearl gray is as
characteristic as the black, white, gray
and pink of Velazquez... The Dutch
lacked imagination, but they had
extraordinary taste and an infallible
sense of composition.

Vincent van Gogh, letter to Emile Bernard, July 1888.

Nor should it be forgotten that Joannes had inherited an art dealership from his father and that he also received a share of the income from his mother-in-law's properties. This financial independence enabled the still at home time of Vermeer's death of a total of twelve, according to his widow. Thus the legend of the impoverished, unknown painter is wide of the mark.

Since the explosion of the powder magazine that had cost Fabritius his life and destroyed part of the city in 1654, a number of artists had moved abroad and the already tight art market shrank even further. Nonetheless Vermeer maintained the reputation indicated in Arnold Bon's poem.

Entries in the diary of the wealthy aristocrat Pieter Teding van Berckhout, who called on Vermeer twice in 1669, tell us a little more about this reputation. Noting that on 14 May, finding himself in Delft, he met "an excellent painter named Vermeer who showed me curious works of his own", Van Berckhout adds that on 21 June he had "been to see a famous painter named Vermeer, who showed me samples of his work, of which the most striking, most curious feature is the perspective." These and other diary comments on meetings with Holland's best painters are invaluable, in that they offer proof that Vermeer had a real place among them and that he was above all appreciated for his use of perspective.

On 13 February 1670, after the death of his mother, he inherited the Mechelen Inn, which his mother had rented out. Vermeer did the same, and the following year he also received the relatively large sum of 648 florins from the will of his recently deceased sister Gertruyd.

Woman in Blue Reading a Letter,

c. 1663–64,

oil on canvas, 46.6 x 39.1 cm,

Rijksmuseum, Amsterdam.

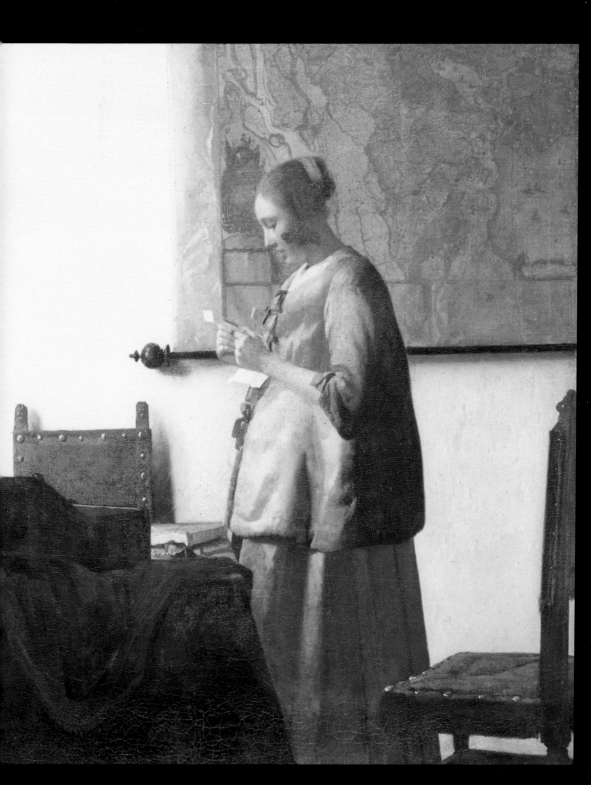

Its weight in gold…

Henceforth Vermeer's women no longer have gallant tempters, play music: alone now, they devote themselves to various tasks or everyday leisure activities. *Woman in Blue Reading a Letter* doubtless shows the painter's pregnant wife Catherina reading a letter. Catching the light directly, her attentive face and the upper part of her body are set against the map already seen in *Officer and Laughing Girl*, so she is in the room where Vermeer usually painted. The chairs, the small chest on the table, the pearl necklace and a thick notebook are among the painter's familiar objects, and the draped fabric in the foreground is found in several pictures.

After studying at length the picture by the "man named Ver Meer", Van Gogh wrote to Émile Bernard in 1888: "The palette used by this strange painter is blue, lemon yellow, pearl gray, black and white. True, his few works may show all the richness of a full palette, but his use of lemon yellow, pale blue and pearl gray is as characteristic as the black, white, gray and pink of Velazquez."

Catherina is even more visibly pregnant in *Woman Holding a Balance*, painted, like the picture just men-tioned, between 1664 and 1666. Here the stillness of maternity makes way for the equally solitary image of a woman doing something: between the thumb and index of her right hand she is holding a balance used for weighing gold, but the pans are empty. Is there a symbol here? Her jacket is open over the meaningful swell of her belly, and her face is full of the attention required by the business of keeping the two pans balanced.

On the table are not precious stones but gold coins, doubtless those the young woman is preparing to weigh, together with necklaces spilling from the chest and the carpet we already know from other Vermeers.

Albert Blankert is emphatic that the theme of the woman holding a balance is a Delft tradition, and in fact it is used several times by Leonard Bramer. Works from the same period by Willem de Poorter and Pieter de Hooch also show a woman weighing gold.

Without question we are being shown here the prosperity of the Calvinist low countries, then considered one of Europe's richest provinces. The Dutch East India Company, founded in 1602, was making a fortune for its shareholders and the Amsterdam Stock Exchange was a very busy institution.

Gérard Dou (1613-75)

Man Holding a Balance,

1664, oil on wood, 28.5 x 22.5 cm, Louvre, Paris.

The weigher of gold was a subject as dear to Dutch painters — especially in Delft — as to their Flemish counterparts. The balance, caskets and other instruments, and the attentive, sometimes greedy faces, combine to provide a highly specific view of the individual concerned. Vermeer excludes the trivial, but not the ulterior motive: his *Woman Holding a Balance* — doubtless his wife — is pregnant: could she be weighing up the future on those curiously empty pans?

Pieter de Hooch (1629-84)

Woman Weighing Coins,

c. 1664,

oil on canvas, 62.9 x 54.8 cm,

Staatliche Museum, Gemäldegalerie, Berlin.

The 17th century was a golden age in Holland. The country's Calvinist region was prosperous and the Dutch East India Company, founded in 1602, was making a fortune for its shareholders. Yet the subject of this painting by Vermeer's rival de Hooch is no speculator: time seems to stand still in the meticulous gestures of this calm, attentive middle-class woman, whose simplicity goes hand in hand with a pleasing elegance.

Woman Holding a Balance,

c. 1662-63.

oil on canvas. 40.3 x 35.6 cm.

National Gallery of Art. Washington.

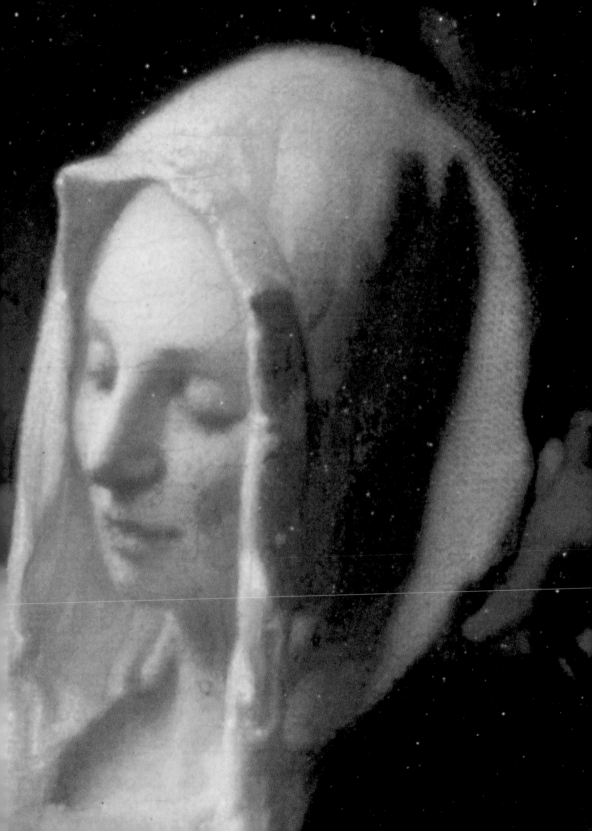

Woman with a Pearl Necklace,

c. 1664,

oil on canvas, 51.2 x 45.1 cm,

Staatliche Museen, Gemäldegalerie, Berlin.

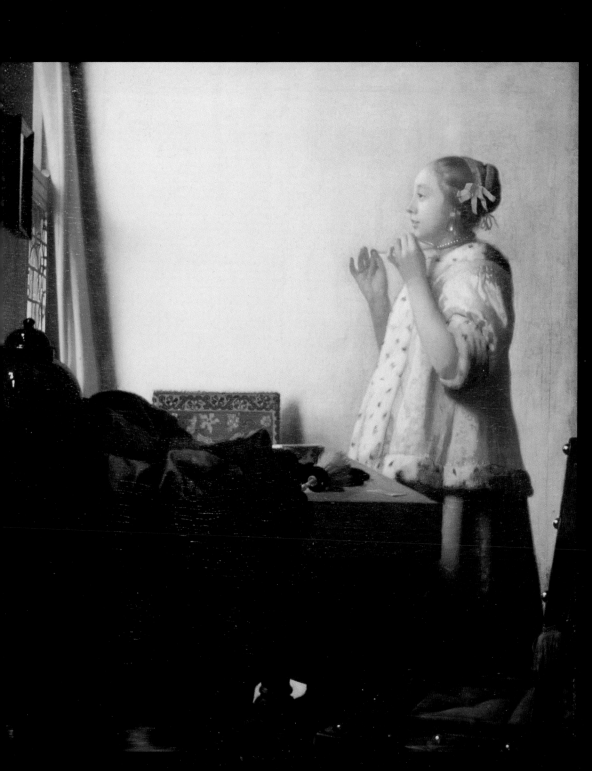

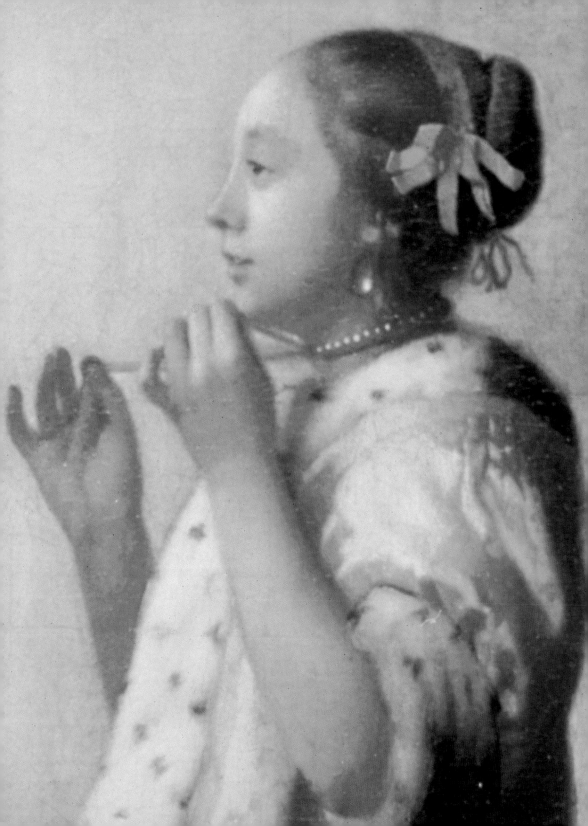

A Lady Writing,

c. 1665,

oil on canvas, 45 x 39.9 cm,

National Gallery of Art, Washington,

(gift of Harry Waldron Havemeyer and Horace Havemeyer, Jr.).

The figure in *Woman Holding a Balance* partly blocks our view of a large *Last Judgment* on the wall. In her concern with worldly goods, should not this weigher of gold stop to reflect that on Judgment Day souls will weigh heavier than gold or pearls? At the same time the significance of the latter painting remains uncertain: some commentators see in it an allegory of the vanity of worldly possessions, also illustrated by the mirror, a frequently used symbol at the time. Set as it is on the left edge of the picture, the mirror reflects nothing neither for the woman nor the viewer; indeed the latter can hardly see it at all. According to Daniel Arasse, "the mirror of truth" reflects into the interior the picture: more than "contemplative" this Vermeer is "reflexive", with its meaning and the unlikely revelation of its content being played out within the image itself. After all, is not every work by this painter a reflection of itself?

Woman with a Pearl Necklace is another typical example of Vermeer's use of a young woman standing facing the light in the closed world of a room with a window and a long yellow curtain. On the table are various objects, among them an odd little duster of yellow horsehair; fabrics and cushions make up a dark foreground in front of a large blue Chinese vase. The model – no longer the painter's wife Catherina – also poses for *A Lady Writing*, in which we find the same face with its turned-up nose, the same hairstyle with its little ribbon, and the same yellow jacket with the ermine trim. The light, however, is not the same: bright and sharp in *Woman with a Pearl Necklace*, it is subdued in *A Lady Writing*, where only the subject's upper body is lit. She holds a quill pen in her hand, but the face turned towards the viewer is full of surprise at being disturbed by an intruder. In the large, dark painting on the wall behind her we can make out a bass viola and a skull. This "vanitas" is attributed to Cornelis van Meulen or Evariste Baschenis.

On the table in *Woman with a Lute* we find Vermeer's usual still-life objects: draped fabric and books. The same model as in the pictures just discussed poses with her ermine-trimmed jacket and a large pearl earring, but the blurriness of the face and the drawing of the lute give the impression of an unfinished work. On the wall is a large map of Europe and the light comes through a window with a blue curtain.

You told me you had seen some of
Vermeer's pictures; so you realize that
they are all fragments of one and the
same world, that whatever the genius
that goes into this recreation, it is
always the same table, the same
carpet, the same woman, the same
new and unique beauty, a total
enigma at a time when nothing else
resembles or explains it, unless one
seeks not to establish some relationship
between the subjects, but to isolate
the particular impression
the color produces.

Marcel Proust, In Search of Lost Time,
Gallimard, 1923.

Hendrick Ter Brugghen (1588-1629)
Woman with a Lute,
c. 1624-26,
oil on canvas, 71 x 85 cm,
Kunsthistorisches Museum, Vienna.

There seems to be a certain unease in the pleasure the lute brings this young woman. Vermeer's lady lutenists play calmly, studiously, in the half-light coming through a window; and unlike this one — but then ter Brugghen was a Caravaggist — they did not wear extravagant, low-cut dresses. Is there a theatrical influence here? Or maybe an attempt to establish a working-class type, one going counter to the hypocrisy of a bourgeoisie whose "musical parties" were excuses for a mix of discreet flirtation and sophisticated chit-chat?

**Gerrit van Honthorst
(1590–1656)**

*A Young Woman Playing a Viola da Gamba,
oil on canvas, 82.5 x 66.5 cm,
Private Collection.*

Honthorst discovered the new
Caravaggist esthetics in Rome and
much of the work he did once
back in his home town of Utrecht
betrays its influence: popular real-
ism, chiaroscuro and half-length
portraits in the great Italian deco-
rative tradition. Music was the
perfect foil for this young woman
who, unlike Vermeer's chaste
females, has no scruples about
showing her bosom to advantage.

Woman with a Lute,

c. 1664,

oil on canvas, 52 x 46 cm,

Metropolitan Museum of Art, New York

(bequest of Collis P. Huntington).

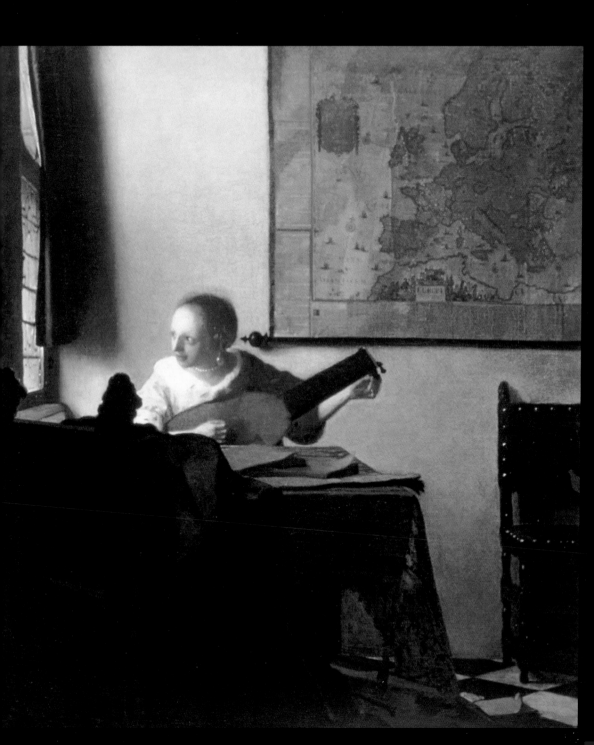

Girl with a Red Hat,
c. 1665,
oil on wood, 22.8 x 18 cm,
National Gallery of Art, Washington.

Girl with a Flute,
c. 1665-70,
oil on wood, 20 x 17.8 cm,
National Gallery of Art, Washington.

7

A change of style

Vermeer's women are gentle-looking, a trifle dreamy and very demure. As the image of a refined society ruled by morality and religion, we can hardly imagine them in a state of undress or at a drinking session. Silent presences, they lead peaceful, ordered lives in a narrow world in which everyday acts — a love affair, a concert, letter-writing or the chords of a lute — have a near-sacramental value. Taken at face value these scenes are somewhat monotonous, limited in their action, confined to repetitive poses and a banal or simplistic view of human relationships. For Vermeer, moralist rather than psychologist, what counts is neither the subject nor the genre — history, still life, portrait — but *painting*. As André Malraux would put it, Vermeer gives the world "as a fundamental value, painting itself."

Now the letter replaces the lute: a woman writes it, hands it to a servant or receives it. In *Mistress and Maid*, the maid is shown in delicate, finely rendered lost profile, while the yellow, ermine-trimmed jacket Vermeer uses for his models and the turquoise drapery of the table are most pleasingly matched. In *Lady Writing a Letter with Her Maid*, the maid is close to her again in a skilled interplay of light and shade. There is no exaggerated contrast, no excessive detail, but a stylization of the forms which in *A Lady Standing at a Virginal* achieves a rigorous restraint in the relationship between figure and volume, be it in the vertical folds of the skirt, the sober rectangle of the virginal and the scene painted on its lid, or the pictures on the wall — a naked Cupid holding up a letter, and a fresh, green landscape in a heavy gold frame. The straight lines and right angles find perfect balance. To the left the window closes off this juxtaposition of light-and-dark patches of color, of cool colors and reflections in which the lady in all her finery turns towards us, playing her scales as she awaits her partner.

Here, probably after 1667, Vermeer is trying a new style whose characteristics can be found in *The Love Letter*. This is one of his most complex, most deeply

Mistress and Maid,
c. 1665-70,
oil on canvas, 92 x 78.7 cm,
Frick Collection, New York.

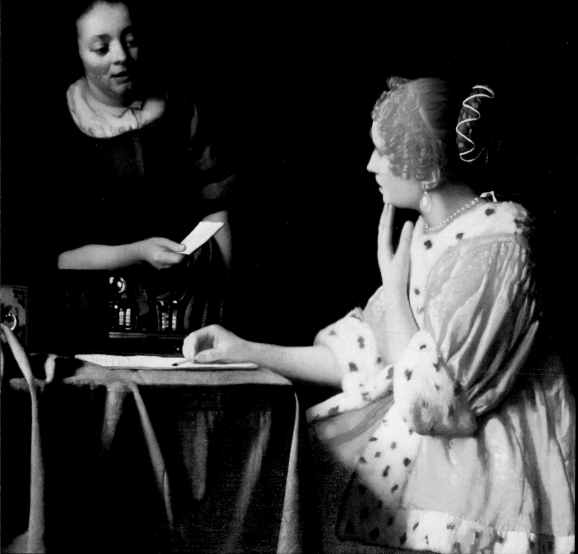

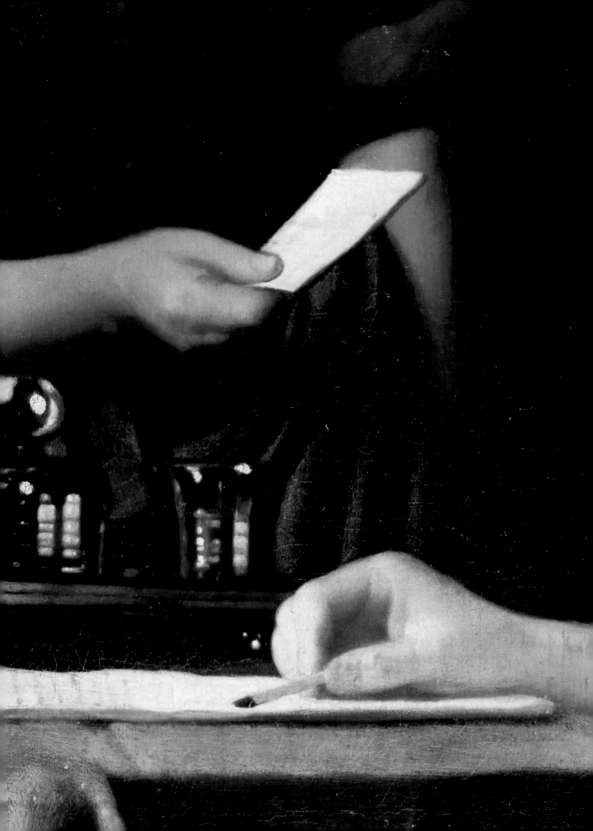

Lady Writing a Letter with Her Maid,
c. 1670,
oil on canvas, 72.2 x 59.7 cm,
National Gallery of Ireland, Dublin.

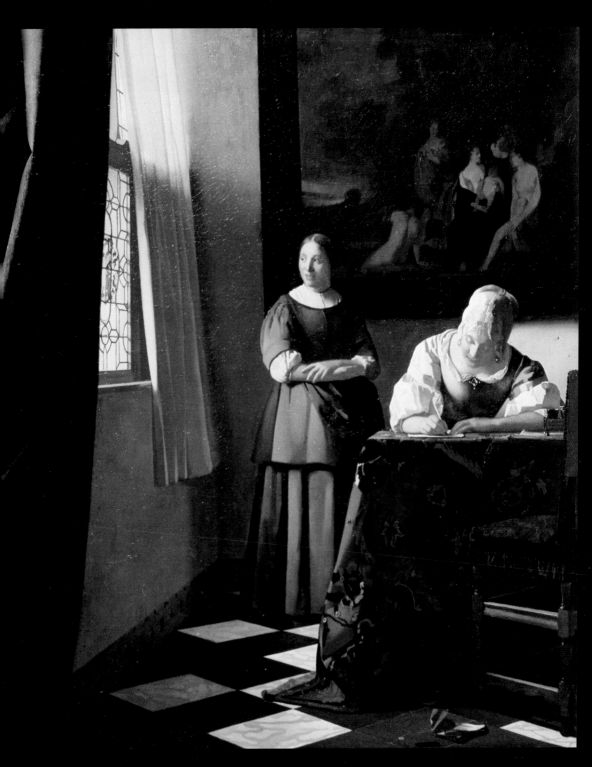

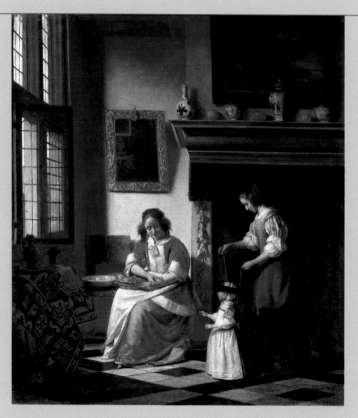

Pieter de Hooch (1629-84)
Learning to Walk,
1670,
oil on canvas, 67.5 x 59 cm,
Museum der Bildenden Künste, Leipzig.
In this scene the painter shows himself a sensitive, amused observer of the minor episodes of everyday life taking place in a well-off, middle-class setting. The broad geometrical planes and the straight lines divide up and shape the under space the uniform light coming from the window. In this enclosed world the figures point to a lifestyle that is protected, peaceful — a fraction too much so? — and too sartorially exotic to be completely true.

meditated compositions, with its main character seemingly at the center of a triptych as we observe her between two theater uprights hung with draperies.

The room is generously lit, the floor is tiled and the fireplace is adorned with Ionic columns and a broad panel of gilt leather. Wearing her pearls and the habitual yellow jacket trimmed with ermine, the woman has been interrupted in her playing of the cittern by a maid bringing a letter. A. P. de Mirimonde has suggested a scenario – a singer canceling by letter – which we are free to accept or reject, for once again the picture remains an enigma.

What is certain is that the lady – not in the first bloom of youth – seems puzzled as she looks enquiringly at her maid before opening the letter. As so often, Vermeer accompanies his scene with two symbolic paintings on the wall: the upper one shows a man walking away into a wooded landscape, while below a sailing boat leans in the wind under a stormy sky.

Here word and gesture – action, attention, unease, surprise, embarrassment, expectation – are frozen, suspended. But whatever meaning we attribute to these staged scenes, the symbol they conceal and the narrative they suggest are first and foremost acts of painting: slow, patient operations Vermeer pursues from one room of his house to another surrounded by his continuously pregnant wife, his crowd of children, the tutelage of his mother-in-law and the family problems with debts, loans and inheritances. The recluse does not escape into his city to paint: rather he seeks out another kind of reclusion in the soft light of the morning.

The Love Letter,
c. 1669-70,
oil on canvas, 44 x 38.5 cm,
Rijksmuseum, Amsterdam.

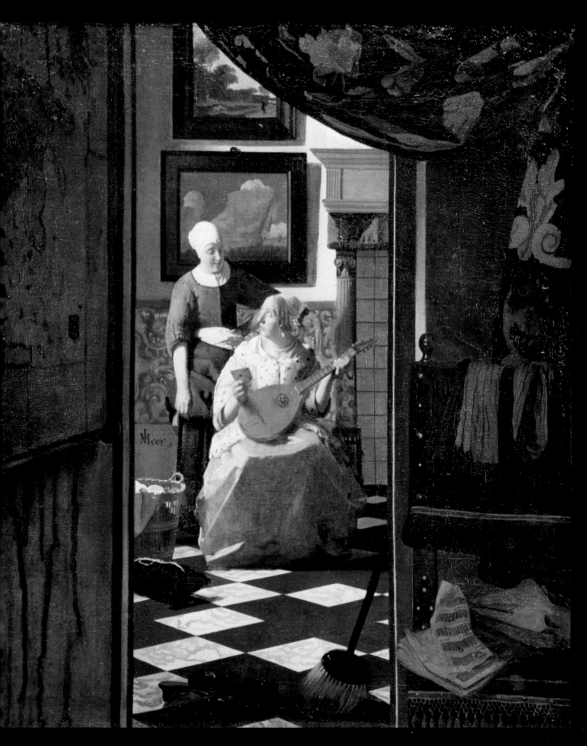

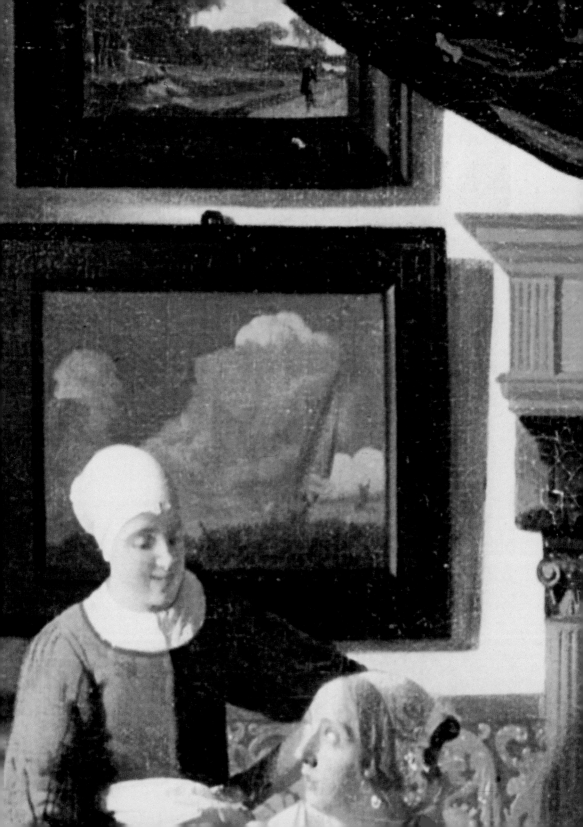

A Lady Standing at a Virginal,
c. 1672-73,
oil on canvas, 51.8 x 45.2 cm,
The National Gallery, London.

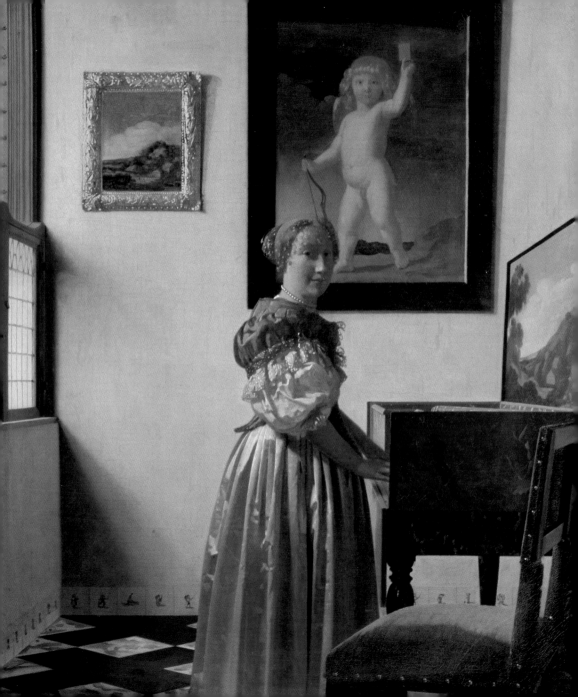

Elusive,
hidden
moments

In any Vermeer painting there is something elusive: those look-alike women, the objects that are always the same, the mirrors reflecting nothing, the half-open or closed windows that give no hint of what lies outside — all generate a kind of permanent ambiguity. Slyly, as in the theater, the painter plays not with suggestion, but with frustration: constantly slipping out of sight, resorting to secrecy and distance, playing close to his chest and ensuring that his characters do the same in their actions, gestures, expressions and poses. The meaning of his little plays is always withheld, as if it did not concern us; and his life has proved just as elusive, despite the efforts expended on an enormous mass of archival material by John Michael Montias . But his use of paint redeems everything...

Vermeer's paint is creamy, stylish and glossy — the direct opposite of the meticulous, monotonous "finish" of his contemporaries. It has the bitter sweetness of blood in its chromatic harmonies, its proportion of line and plane, its chiaroscuro in which light and shade are one, its cozily confined atmosphere where people and things vibrante; in the banality of an amorous advance, of a little concert among friends, of an aura of shared tenderness. Everywhere the painter is in league with his creations.

In these zones of enigmatic conviviality Vermeer shapes his miraculous moments — the gracefulness of a face, the expectation in someone's eyes, a ripple of fabric, the texture of a dress, an unexpected effect of the light, the gleam of a pearl...

This painter who never really typecast his characters reveals a particular attachment to facial expression and the language of a body totally immersed in what it is doing in two works that can be regarded as companion pieces — The Astronomer and The Geographer, both from 1668 or 1669. Staggering microcosms of scientific instruments, silent study and scholarly concentration, these works are also a tribute to the golden age of science and thought that was the 17th century in Holland — the age of Huygens, Spinoza, Delft's own Van Leuuwenhoeck and Descartes, to name but a few.

The Astronomer,
c. 1668,
oil on canvas, 51.5 x 45.5 cm
Louvre, Paris.

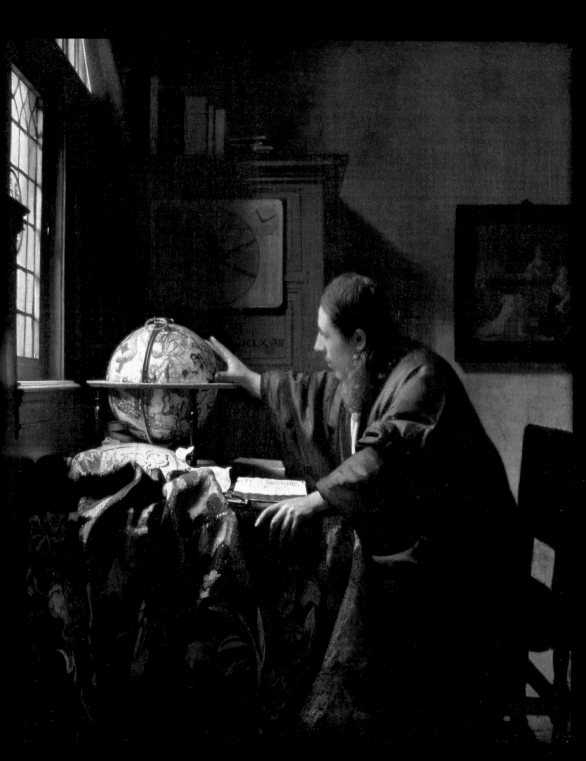

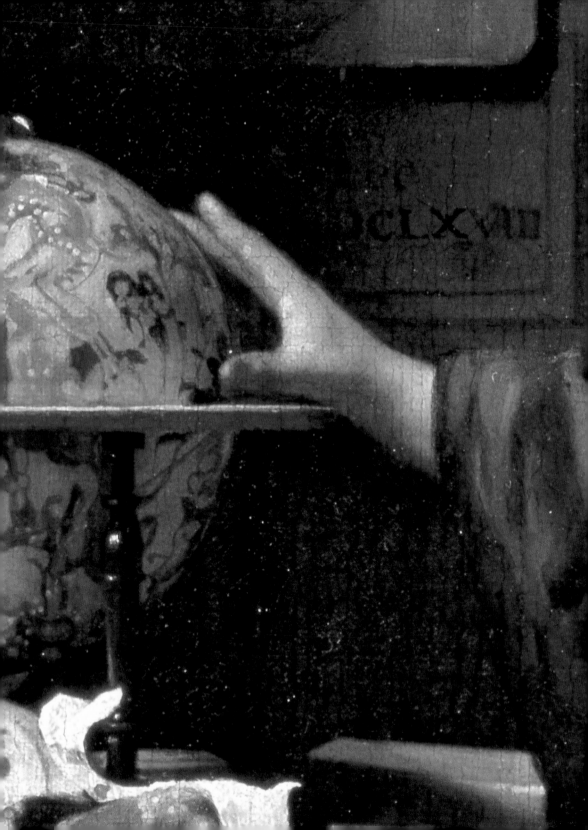

The Geographer,

c. 1668-69.

oil on canvas, 52 x 45.5 cm.

Städelsches Kunstinstitut, Frankfurt.

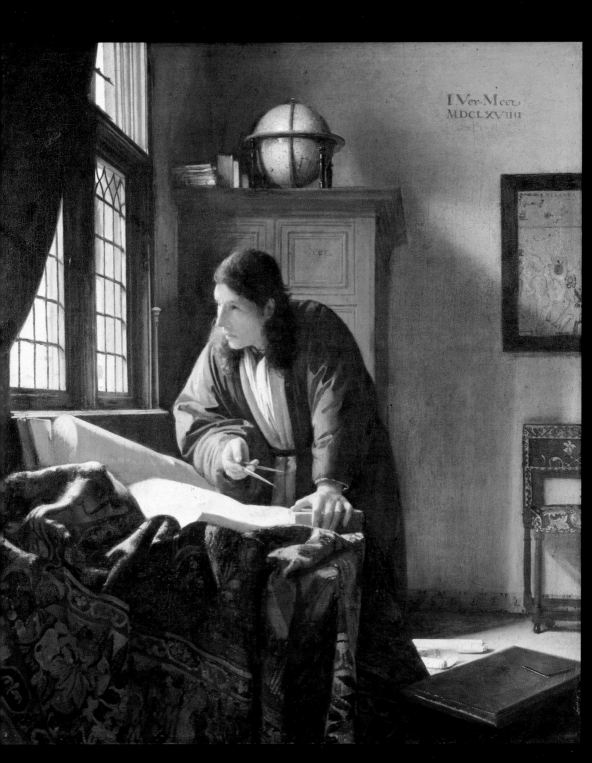

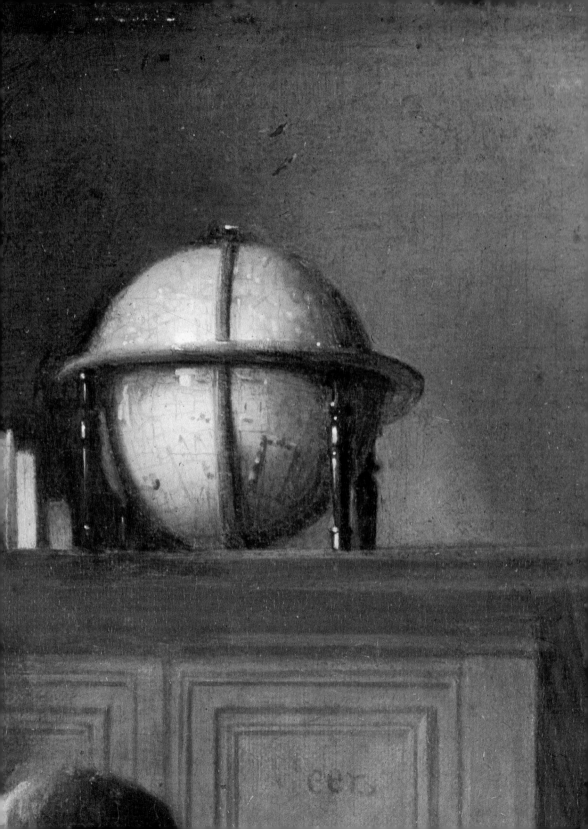

I.Ver-Meer
MDCLXVIIII

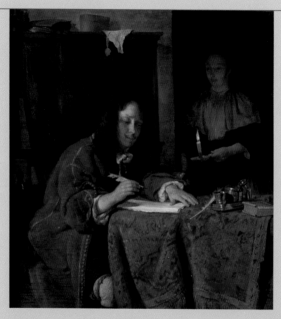

Below: **Gerrit Dou (1613-75)**

The Astronomer,

1660,

steel engraving, colored c. 1850 by Appold after a painting by Gerrit Dou, 14 x 17.2 cm,

collection Archive F. Kunst & Geschichte, Berlin.

Candle in hand and the light of inspiration in his eye, this old man — reminiscent of those of Rembrandt, Dou's teacher — scans the stars. Like Vermeer's Astronomer he has his other hand on a globe of the world. In Holland's golden age the geographer and the astronomer — explorers of earth, sea and sky — fascinated artists and non-artists alike, but Dou's version is too picturesquely facile: this astronomer is closer to the theater than to science.

Above: **Gabriel Metsu (1629-67)**

The Writer,

undated,

oil on canvas, 28 x 26 cm,

Musée Fabre, Montpellier.

Wearing indoor clothes and with long black hair falling to his shoulders, the letter-writer is hard at work as his maid, that traditional figure of domestic life, stands by with a candle. The lighting emphasizes the still life and the splendid red carpet whose generous folds — as in several works by Vermeer, who influenced Metsu — make up the foreground.

After the lute and the letter comes the globe of the world that the Astronomer turns with a sweeping gesture of the right hand. He is wearing a green dressing gown and in his enthusiasm his left hand clutches the table and the branch-patterned carpet that covers it. The book, open at its first two pages, is the third volume of Adriaen Metius' *The Investigation and Observation of the Stars*. A compass and an astrolabe are also on the table and the globe is a replica of one made by the Hondiuses, a famous family of Dutch cartographers.

On the wall is the same *Moses Saved from the Waters* already seen on a larger scale in *A Lady Writing*. A closet is set in the corner and its middle panel bears a signature, "I Meer", whose authenticity is contested. Attached to the upper panel is a planisphere, with hands marking angles on its dials.

Icons of thought:
the Astronomer and the Geographer

Eye and hand move in the same direction, towards the same act of possession: the Astronomer and the Geographer are one with the subject that obsesses them; their shared investigation fills their minds and concentrates their gaze. The hand of one is sounding the world, feeling the roundness of it with its continents and constellations; the hand of the other, holding a compass, quizzes a map of the heavens open on a table. A globe of the world sits on top of the closet.

In the course of a few works Vermeer has abandoned a "genre" style – non-narrative but not without its own hidden agenda and in which woman plays the main part – as well as symbolic musical subjects. He has moved to a more inward form of expression in which, with the same meditative intensity, he affirms the power of thought via a grave attentiveness of gaze and a tensely physical reaching-out that extend it and make it explicit.

A similar concentration is to be found in *The Lacemaker*, in the Louvre, in which Vermeer's attention is utterly focused on the hands and face of a humble worker bent over her collection of bobbins, undistracted

The Lacemaker,
c. 1669-70,
oil on wood-backed canvas, 23.9 x 20.5 cm,
Louvre, Paris.

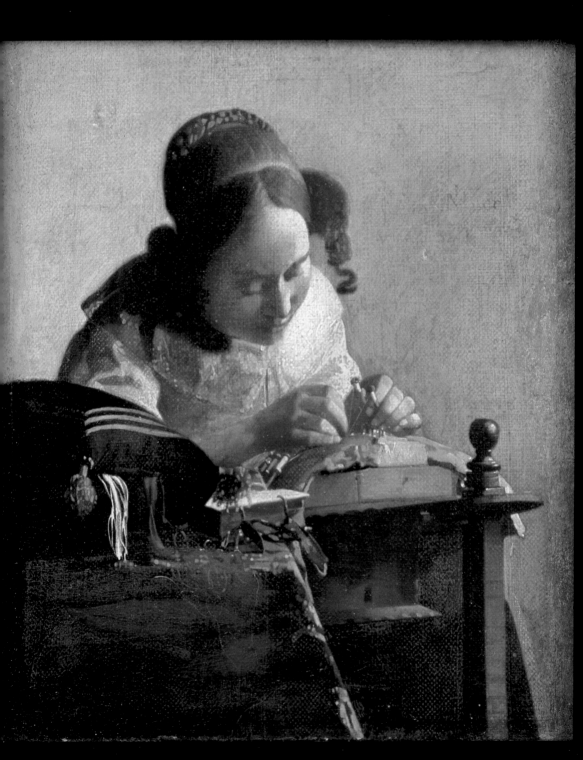

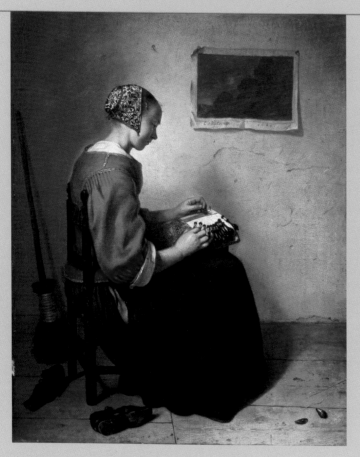

Caspar Netscher (1639-84)
The Lacemaker,
1664,
oil on canvas, 33 x 27 cm,
Wallace Collection, London.
Conventional in style, Netscher's lacemaker is less concentrated, less absorbed than Vermeer's. Why are the shoes lying on the floor, together with mussel shells, in a bare room with a picture simply pinned to the wall? Someone has suggested the aftermath of an orgy involving this modest-seeming girl, but is this not seeing things in the worst possible light? At the same time, the objects reflect a strange symbolism.

by any outside intrusion. On the table beside the harmoniously spilling hanks of thread, the sewing cushion, some scraps of fabric and the usual green patterned carpet contribute their subtly contrasting interplay of blues, reds and yellows. And the whole composition is sprinkled with brilliant little points of light on the collar, the ribbons, the thread and the folds of the carpet, while the lacemaker's face remains slightly in shadow.

In this admirable triangular composition Vermeer has achieved one of his supreme expressions of silence, solitude and pure poetry. Subject and object are merely the medium for the act of painting, which owes its absolute beauty solely to its own reality.

In 1661 work had begun on building new premises for the Delft branch of the St Luke's Guild. As a guild official, Vermeer was directly concerned with the architectural and decorative choices involved and wanted painting to be given real symbolic emphasis. To take advantage of the opportunity he decided, not to show himself a work in his studio, but to create a kind of *Allegory of Painting* – or more simply, the *Art of Painting* now in the Kunsthistorisches Museum in Vienna.

Here he foregrounds the practical business of the artist, surrounding him with the conventional paraphernalia. It should be noted that the empty-eyed plaster mask on the table is a tribute to the art of the sculptor – but is also a theater prop.

Seen from behind, the painter is wearing the traditional headpiece and garb of artists from the immediately preceding period. On the other hand, nothing here is reminiscent of a studio: there is no palette, no paint, no tools of the trade's except the brush and the mahlstick. Thus the painter – often taken as being Vermeer himself – is wearing timeless clothes and working in a timeless place, a theater set. In front of him poses a girl with lowered eyes, wearing a laurel wreath and holding a large book and a trumpet. Is she Fame, or Clio, the muse of history? Or does she stand for Painting?

This is unquestionably the most dense of Vermeer's works in terms of hidden intentions. He himself gave it the title *The Art of Painting* and what we have is a kind of personal interpretation, or confession, or reading of his art and himself. And contrary to the expectations of his fellow guild members, who hoped it to be a gift which could be hung prominently in their new premises, he kept it for himself.

The Art of Painting,
c. 1666–67,
oil on canvas, 120 x 100 cm,
Kunsthistorisches Museum, Vienna.

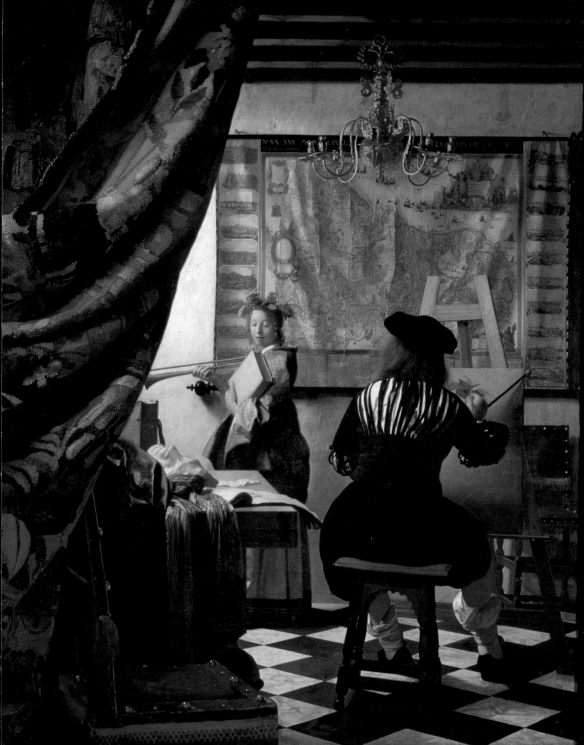

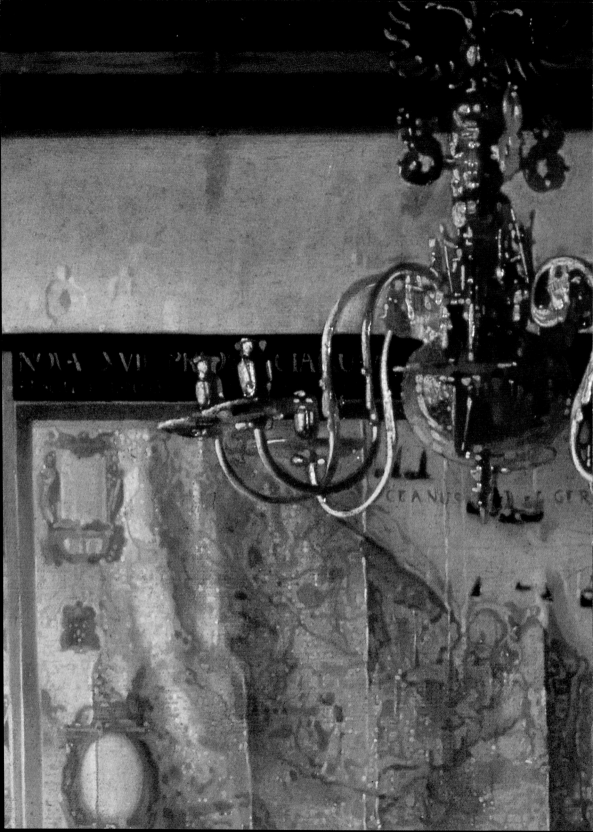

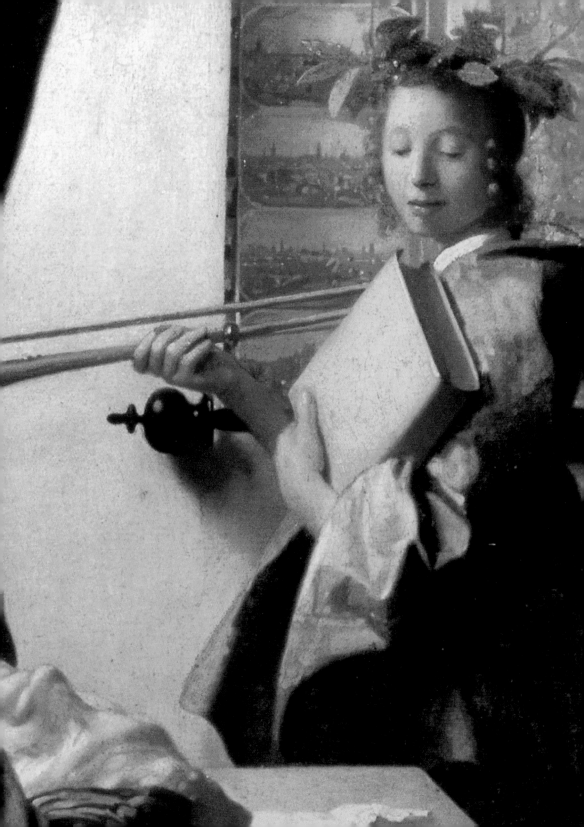

A tribute
to painting
and to the painter

The painter is painting, his hand almost touching the canvas in anticipation of the brushstroke. Everything is in this hesitation, born of inspiration. The painter paints slowly and surely, without getting carried away – an allusion to the exaggeratedly spirited expressiveness of some of his fellow painters. The atmosphere is one of utter serenity and peace as Vermeer gives his lesson in wisdom: painting is not a frenetic business, and should jolt neither the eye nor the mind.

Because of the issues raised by the picture, the painter drew on Cesare Ripa's *Iconologia*, originally published in Italian in 1603 and translated into Dutch in 1644. In his book Ripa provided painters with a repertoire of emblems for mythological, philosophical and historical contexts, and Vermeer's principal borrowing here is the charming figure of the young woman, inspired by that of Glory in *Iconologia*. However, dressed in blue and wearing her laurel wreath, she could also stand for Clio, the muse of history. The fat book is doubtless a "lives of the artists", perhaps Karel van Mander's *Schilderboeck* on Dutch painters.

The laurel wreath and the trumpet may well symbolize Fame and the book History; for Vermeer these emblems were part of the painter's destiny.

A heavy theater curtain folds back to reveal this exchange in the studio, while on the wall is a large map of Holland, bearing a Latin inscription – "New description of the 17 provinces of lower Germany" – followed by the words "Published by Nicolas Piscator". On each side of the map a column of ten small engravings portray Dutch cities. The mention of the 17 provinces means that this map could date from the time when Holland was part of the Hapsburg Empire.

The same thick theater curtain opens once more to the left in *The Allegory of Faith*, dated to 1672-74. The main liturgical and symbolic items are again drawn from the *Iconologia,* and in the background is a Jordaens-inspired crucifixion Vermeer had at home, along with the many other pictures in the inventory made after his death.

It may be that this work was a commission, either from the priests of the Delft Mission or from a Catholic art lover in Calvinist territory. No doubt its the excess symbolic baggage reflects the set iconographic program that illustrates what Cesare Ripa called "the Catholic or universal faith". A "Papist" and an overt opponent of Calvinism, Vermeer makes a statement here about the faith that sustained him and his loved ones.

In terms both of subject and handling this work is in sharp contrast with an oeuvre we know as free of

grandiloquence and quietly rooted in its creator's con-
victions. The odd pose of the central figure – some have
even found it improper – seems equally incongruous
in terms of his repertoire. Semi-swooning, her eyes
rolling upwards and her hand pressed to her heart, the
woman has one foot on the globe of the world; on the
floor lie the crushed Serpent, Death with its arrows bro-
ken, and the Apple signifying original sin. Hanging from
the ceiling by a blue ribbon, a glass ball acts as a con-
vex mirror – but offers no visible reflections.

This is Vermeer's last known work, but hardly the
one that made his reputation. His imagination is limit-
ed and his hand less sure: we sense a slackening-off
on the part of this painter who so fascinated, but now
so disappoints, us. Less in control, he lets his brush
become overloaded, blocking out the outside world.
"A secret flaw appears in the crystal," René Huyghe has
written. Could the explanation be a decline in the
painter's health? Whatever the case, nothing was
working like before.

From silence
into
oblivion

Vermeer died on 15 December 1675, aged 43, and was
buried at the Oude Kerke, the Old Church. Was he ill or
did he die suddenly? We don't known. According to his
wife he had been much affected by the war, the inva-
sion of Holland by France and the subsequent looting
by Louis XIV's troops. During this time he had been
unable to sell a single painting and his sideline as a
dealer – several other Dutch masters earned income
the same way – had suffered as well. With a large fam-
ily to feed Vermeer fell victim to despair and his state
of depression hastened his end.

On 27 January 1676 Catherina had to sell two
works to the baker Henrick van Buylen to meet a
debt of 217 florins, but reserved the right to buy
them back with annual payments of 50 florins.
Others had to be sold off cheaply and she had to
deposit 26 pictures with a Haarlem art dealer as
security for a debt of 500 florins owed to the grocer
Jannetje Stevens. In the meantime the post-mortem
inventory of Vermeer's assets had revealed, in addi-
tion to all sorts of different items, a number of paint-
ings whose identity – with the exception of three

The Allegory of Faith,

c. 1671–74,

oil on canvas, 114.3 x 88.9 cm,

The Metropolitan Museum of Art, New York.

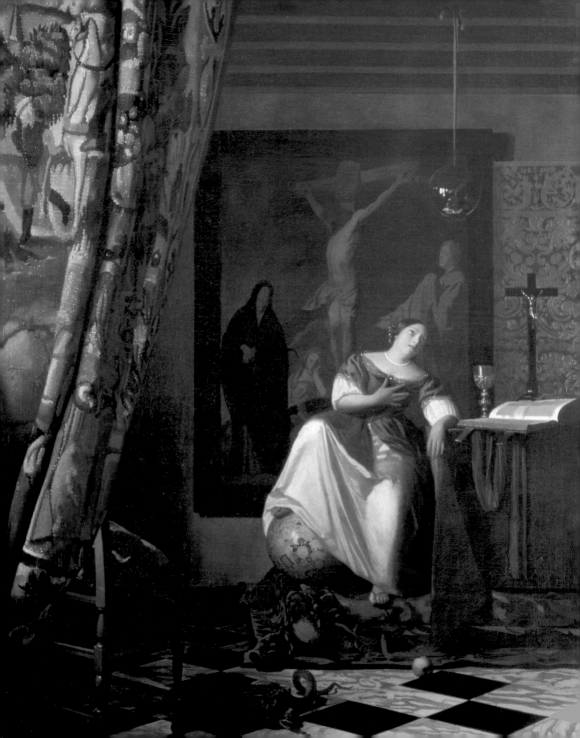

Willem van Mieris (1635-81)

Fainting-Fit,

1695,

oil on canvas, 23.5 x 20 cm,

Hermitage, St Petersburg.

What is the symbolism of this curious — and doubtless satirical — scene? Willem van Mieris was from Leiden; he joined the painters' guild in 1683 and died there in 1747. This work reflects an era far removed from that of Vermeer, with its near-Mannerist elongation and twisting of the figures, and the folds of fabric highlighting the sculptural nudity of the body. Only the ornate carpet with its elegant folds reminds us of Vermeer and the Dutch taste for Oriental motifs.

by Fabritius and two portraits by Hoogstraten – remains unknown.

On 30 April 1676, Catherina petitioned the authorities, declaring herself unable to meet her creditors' demands because her husband had been almost totally unable to work during the French occupation. The High Court adjourned her debts and the Delft scholar van Leuuwenhoeck was chosen to administer her assets and give satisfaction to her creditors as quickly as possible.

When the printer Jacob Tissier died, the 21 Vermeers he had inherited were put up for sale as part of a total of 134 pictures. French critic and Vermeer's "rediscoverer" Thoré-Burger tracked down the catalog, from which we learn that *The Milkmaid* went for 60 florins, *Woman Holding a Balance* for 55 and the *View of Delft* for 200. At the same sale, however, a *Head* by Rembrandt struggled to sell at 7 florins and a *Beheading of John the Baptist* attributed to Fabritius was knocked down at 20.

Then came oblivion, both for the oeuvre and its creator: in 1719 *The Milkmaid* changed hands at 126 florins, while a Gerrit Dou fetched 6,000. What lay behind this? Why was this art of silence, meditation and mystery ignored and forgotten? Was Vermeer some kind of anomaly in 17th-century Holland, even if he had given expression to its innermost soul? And what of this approach to painting in which, for the first time in Western art, the visible subject became the focus for the viewer's eye, stripped of all trivial narrative, picturesqueness and artifice?

Vermeer had succeeded in giving things their everyday identity and fullness; as in the theater, he had made a world in miniature. He painted not the obvious, but what might be obvious in imitation and the illusion of appearances. And his light was totally his own, never that of anyone or anywhere else.

Time in the oeuvre of Vermeer has nothing Proustian about it. Instead of that complexity, those countless ramifications, those twists and turns, there is a crystalline clarity in which the dizzying poetry of the real is that of the precise mirror-image. In the work of this creator of interiors those seemingly frozen characters are seen performing only the most simple acts, yet they remain dominated, bewitched, under some strange, tyrannical spell. Painting has its way with them; it is painting that freezes them, absorbs them into a space on their scale and embraces us with all the force of its mute emotion.

A look, a gesture – these can suffice to wipe out the frontier between past and present, the separation of the inner from the outer. Coming from some great distance these people are seized by eternity: they are icons of the continuous present.

The paintings emerge from
obscurity

Was Vermeer in fact unjustly ignored and forgotten or is this (relative) indifference just another part of the legend? In the 18th century the northern painters – Dutch, Flemish and German – were far from unknown to connoisseurs and dealers; and the "rediscoverer" of Vermeer in the 19th century was not, as we are told, the "left-wing" journalist Thoré-Burger, but rather – in the late 18th century – Jean-Baptiste Pierre Lebrun, one of the leading society art dealers of the closing years of the monarchy, and best known as the husband of Elisabeth Vigée-Lebrun, who painted the portraits of Marie-Antoinette and the elegant ladies of her time.

A purchaser for the king and people of influence, Lebrun sensed the historical winds of change and knew that the end of the aristocracy, with its money and its taste, would mean the end of his wealthy, noble clientele. Clever, opportunistic and as ready to adapt to political as to artistic change, in 1789 he left France in search of new outlets.

The year 1792 found him at The Hague, where he noticed "the Van der Meer the historians have ignored... He is a very great painter in the manner of Gabriel Metsu. His works are few and are better known and appreciated in Holland than anywhere else... It seems that he was particularly keen on sunlit effects, at which he was extremely successful."

Lebrun was an admirer of Dutch and Flemish painting and even commissioned from Georges Michel, landscape artist and the most Dutch of the French painters, a number of canvases not necessarily destined to be recognized for their originality. That Vermeer had caught his eye is hardly surprising, then, but it is disturbing that he should have been so assertive in his evaluation of him. Some of the painter's works had been on the market in the 18th century: *Woman in Blue Reading a Letter* had been through the hands of the dealer de Brais in 1742 before its acquisition by the Elector of Saxony in Dresden; and between 1710 and 1760 the Duke of Brunswick and the King of England had acquired in all four Vermeers – just which ones was not clear at the time, but the paintings were regarded as remarkable. Thus "Vandermeer" was known to the collectors and connoisseurs of the period.

In 1785, relates Jolynn Edwards, the art dealer Alexandre-Joseph Paillet, a rival of Lebrun, imported two pictures as companion pieces – *The Astronomer* and *The Geographer* – in circumstances that have remained mysterious; they escaped the vigilance, or the interest, of the Comte d'Angiviller, director-general of the Royal Buildings, even though Paillet was his agent.

It was on a business trip to Amsterdam that Paillet bought the two Vermeers – and perhaps other works by the painter – but he was not the only one showing an interest. From 1784 Lebrun began engraving *The Astronomer,* which Paillet had had brought in to France by Louis Garreau, then published in his *Gallery of Flemish, Dutch and German Painters*. Nor did the painting belong to Paillet; on 16 August 1797 it was auctioned together with *The Geographer* and *A Lady Standing at a Virginal* as part of the collection of Jan Danser Nijman.

The Astronomer appeared alone at the Goldemeester sale in 1800, then turned up at Christie's in London in 1863 then in Paris at the sale of the famed Léopold Double collection in 1881, before being acquired by Baron Alphonse de Rothschild, a great collector of the Northern painters. After a succession of mishaps during the Nazi occupation of France it finally came to rest in the Louvre in 1983, joining *The Lacemaker* in the collection of small Dutch paintings.

The Geographer was also sold several times in the course of the 18th and 19th centuries, before finding its present place in the Steadelsches Kunstinstitut in Frankfurt. All in all, then, Vermeer was far from being ignored or scorned.

The *View of Delft* was part of the Jacob Dissier collection in the 18th century, having been acquired, as already noted, for 200 florins on 16 May 1696. The canvas was much admired; copies of it were made and such was its reputation that in 1816 the art historians Van Eynden et Van Willigen mention it in their book on Dutch painting as the only work of Vermeer they knew, apart from *The Milkmaid* and *The Little Street*: "There is also by him a representation of Delft, seen from the South, a marvelous interpretation that has attracted the highest praise... but we do not know where it is to be found at present."

The picture resurfaced at a sale in Amsterdam in May 1822; its reputation was by then so considerable that it was acquired by the State for the substantial sum of 2,900 florins. This was the first Vermeer to enter a public collection, but was it for its artistic qualities or its evocation of Delft? The picture made quite an impression on the public, at a time when still very little was known about its maker.

With Vermeer, for the first time in the history of art, the subject of the picture becomes the thing being looked at.

André Malraux, 1951.

An astute eye

Born the son of a merchant at La Flèche in the Sarthe département in western France, Théophile Thoré (1807-69) is reminiscent of Balzac's Rastignac. Despite the law degree that guaranteed him an honorable career as a provincial magistrate, he thought only of success in Paris society – and after a period when he had only one pair of leaky shoes, he succeeded.

Moving in student circles at the time of the "three-day revolution" of 1830, he drew attention with his political stance, and when victory was won and the jobs were handed out he found himself assistant public prosecutor at... La Flèche!

He did not stay for long, however, driven by ambition back to Paris where his Republican friends welcomed him like the Prodigal Son. Art had so far played little part in his life, but on a chance visit to the Louvre he saw a new future beckoning: introducing the general public to the pictures he himself was enthusiastically discovering. "My chosen field," he wrote to his mother, "is critical journalism: the fine arts, painting, sculpture... and I hope to achieve a certain competence therein. There are few others working in this vein, which will make it easy for me to find a place."

Utterly sure of himself, he read, wrote, made the right connections and became a figure in the "left-wing" press. By diligently visiting museums, looking at pictures and moving in artistic circles he eventually gained access to the Salons and became a specialist. He praised Delacroix and Géricault, was fired with enthusiasm for Dupré, Decamps and Diaz and acclaimed the Theodore Rousseau landscapes that were despised by the academic school he hated.

As another critic, Paul Mantz, wrote, "Thoré was just the man for these battles and burials. He was pitiless with Bidault, totally unresponsive to Watelet's innocence and even Picot left him cold." An avant-garde art critic was born. Although he never actually discovered anyone, Thoré became the herald of the rising generation of 1830. Little by little art and artists came to occupy a place in his life only contested by politics; he wrote in the "revolutionary" press under a variety of pseudonyms, urging liberty for art and victory for Republican ideals, and doing it so forcefully that when the Republic was proclaimed in 1848, Lamartine offered him nothing less than the directorship of the Beaux-Arts, the Paris school of art. Fleeing these new responsibilities, he found himself leading the rioters who invaded parliament on 13 June; arrested, imprisoned and condemned to deportation, he fled abroad, changed his name to Burger and went back on the museum circuit.

The museums of the North particularly appealed to him and he could tell the difference between Flemish and Dutch painters. He later said that on a business visit to Holland in 1842, he had already been intrigued

by the *View of Delft*, by one Jan van der Meer, that he had seen in the Royal Museum.

In exile seven years later, he saw the picture again and made the connection with stylistically similar works, like *The Milkmaid* and *The Little Street* that he had seen in the auction rooms. Driven by curiosity and admiration, he set about researching his discovery more deeply.

A realist
among the
impressionists

Thoré-Burger was ultimately pardoned and on his return to France in 1859, he set about reconstructing the oeuvre of the mysterious Van de Meer. One of the first critics to combine historical investigation with flashes of intuition, he patiently put the puzzle together: comparing signatures, digging into archives, looking through collections, galleries and museums. The outcome was three articles under the name of William Burger, published in the *Gazette des Beaux-Arts* over the period October-December 1866. Vermeer was now officially "discovered".

After twenty years of tenacious research, Thoré-Burger was able to present the painter's oeuvre, with the original catalog and a ground-breaking critical introduction. He made a number of errors, including in his list other artists called Ver Meer or Van der Meer,

but in 1907 the historian C. Hofstede de Groot drew up a new catalog; this was followed, three years later by a substantial and then near-definitive study by Eduard Plietzch.

His successive commentators had credited Vermeer with more canvases than he had actually painted. The 35 currently accepted as being his work are all in museums, including the Louvre in France, the Mauritshuis and the Rijksmuseum in Holland, and the Metropolitan Museum and the Frick collection in New York. We also know of eight paintings that have been lost or remain unidentified: references to them have been found in the 1696 sale catalogue and various sales in the 19th century.

The Vermeer revelation began in the realist climate of the 1830s. In his accounts of the Salons and other writings, especially the letters, Thoré-Burger proclaimed his admiration for the landscape painters Millet and Théodore Rousseau and their "fidelity to nature". He also thought highly of Delacroix for his spirit and passionate attachment to life, and Ingres for his (somewhat excessive) worship of form.

His interest in Dutch painting is summed up in his remark, "Since Holland gained its freedom in the late 16th century, painting there has focused only on manners and private life." Thoré-Burger's fanatical devotion to Vermeer had its roots not only in an enigma that obsessed him, but also in his conviction that authentic art should reflect the everyday existence of ordi-

nary folk. Dutch painting was the perfect example, Thoré-Burger saw in it "life alive – man and his mores, occupations, joys and whims... Ah, this is no longer the cloying mystical art of old superstitions, of theology... the art of princes and aristocrats, solely devoted to the glorification of the tyrants who rule humankind..." Here there are echoes of Baudelaire.

In Thoré-Burger's view Holland had cast off the chains of religion and tyranny to become "a strange new society... like the young American one of today, Protestant and democratic."

This was a new idea for the time, Dutch painting being regarded as the agreeable refuge of minor masters – always excluding, of course, the crushing presence of Rembrandt. Long appreciated, it was to be found in the major collections – Berchen and Wouwermans were the favorites – but for Thoré-Burger it deserved greater recognition as a pioneering force in the history of European art. It was, in his eyes, "art for mankind".

And so Thoré-Burger made himself a reputation both as herald of Vermeer and as a passionate interpreter of the golden age of Dutch painting. Back in France after his period of exile, he found the country shaking off the old ideologies in favor of the everyday realism he had always been so attached to. For him Vermeer, like Courbet and Manet, was a painter of the human condition. When his reviews of the Salons of the 1860s were republished in 1870, he appeared as one of the first art historians to have had faith in what he called "the new revolution taking place in the name of naturalism".

Nonetheless his personal Vermeer – his "sphinx of Delft"– is not quite the one we know today. The ex-socialist identified him with a quest for fraternity and universal happiness. The enormous task Thoré-Burger had undertaken was not solely the rediscovery of a great, forgotten painter, it was also an affirmation of the profound humanity of an artist and a school of painting, of an art of conviviality and brotherhood that could unite the peoples of the world. This was – and it is this that we find odd today – the underlying philosophy of the utopian which Thoré-Burger had never ceased to be, though still remaining an art historian in the old style.

The year 1866 – when those articles appeared in the *Gazette des Beaux-Arts*, and the first Vermeer monograph sprang from the pen of his most passionate advocate – was also the period when the future Impressionists were beginning to make an impact with fresh, sun-charged pictures in which natural light brought the supreme moments of existence singingly to life. Renoir would declare that *The Lacemaker*, along with Watteau's *Embarkation for Cythere*, was the most beautiful picture ever painted; and he, Monet and Pissarro would hail this newly recognized master as their precursor. Van Gogh was stunned by his technique and his use of color. And then the hack critics moved in.

There is in Vermeer's craft an Oriental patience,
a capacity to conceal the meticulousness and sheer
skill that is to be found only in the painting,
lacquerware and stone carving of the Far East.
The color and texture of a Vermeer completely satisfy that
sensual appetite, that yearning for nourishment we all can
feel, just a little, on entering a museum. But once tasted,
so to speak, this chromatic and textural lusciousness takes us
far beyond any mere epicurean pleasure. For all that
Vermeer's color comes to us painstakingly 'simmered'
to a smooth, flawless consistency, for all its ardent
commitment, awareness and utter precision,
it remains natural. Having first suggested the tactility
of things like enamel, jade, lacquer and polished wood,
then perhaps some delicately complex cream, paste
or liqueur, it ultimately brings to mind the living, natural
world: the heart of a flower, the skin of a fruit, the belly
of a fish, the agate eye of certain animals; but above all
it brings to mind the very source of existence,
it brings to mind blood.

Jean Louis Vaudoyer, "Mysterious Vermeer", L'Opinion,
April–May 1921.

Young Woman Seated at the Virginal,

c. 1670,

oil on canvas, 25.3 x 19.9 cm,

Private Collection.

On 7 July 2004, Sotheby's in London offered for sale *Young Woman Seated at the Virginal*, the first work by Vermeer to come on the market since 1921. Dated to c. 1670, the painting shows a young woman facing the viewer dressed in an off-white satin dress and yellow shawl, wearing a red hairnet and . The sale came only after years of patient scholarly research had allowed definitive attribution of the small canvas to the master of Delft. In March 2001 *Young Woman Seated at the Virginal* was shown at The Metropolitan Museum in New York, and later in London, to allow comparison with other, already authenticated, Vermeers. Estimated at $5.5 million, it was ultimately sold to an anonymous art lover for $30 million. In financial terms this puts it in fifth place for works by the masters sold in recent decades.

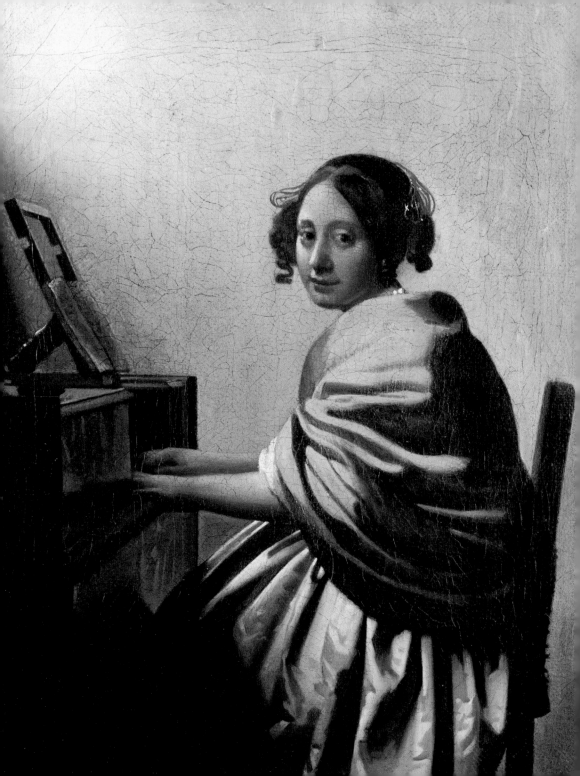

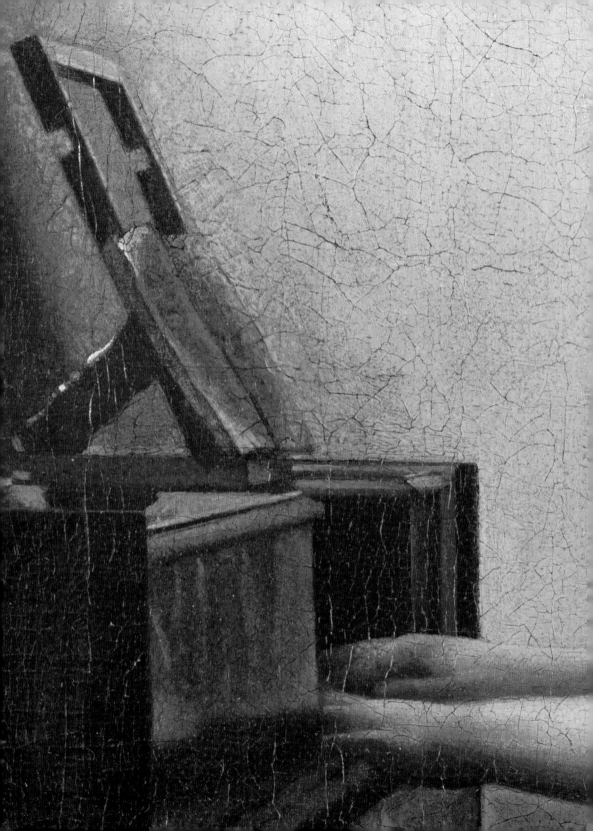

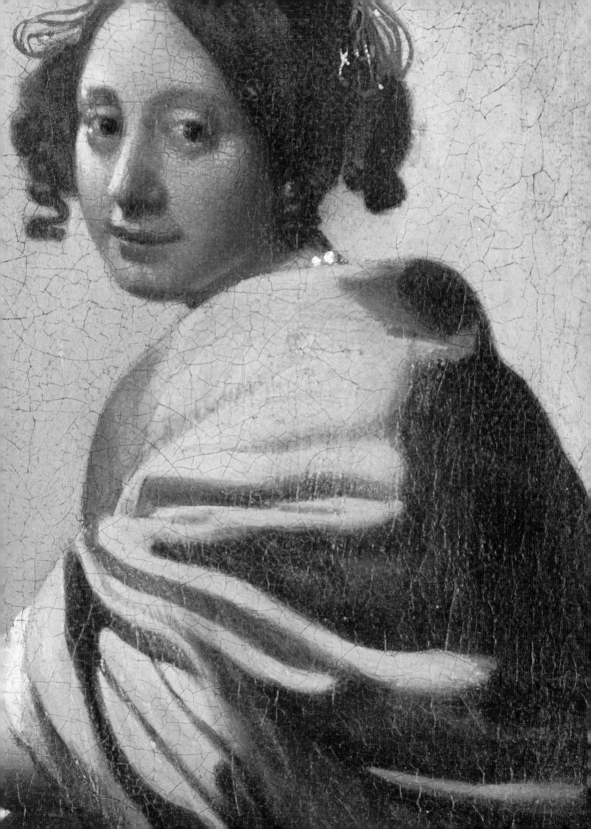

Photographic Credits

Archives : p 18, 95.

Akg-images: cover, 12, 16 (down), 21, 23, 24/25 (detail), 26/27 (detail), 41, 42/43 (detail), 44, 46, 65, 66/67 (detail), 68/69 (detail),73, 74/75 (detail), 76, 79, 80/81 (detail), 82/83 (detail), 84 (up), 86/87, 88/89 (detail), 97, 98/99 (detail), 100/101 (detail), 120, 123, 124/125 (detail), 126/127 (detail), 129, 130/131 (detail), 132, 139, 141, 142/143 (detail), 145, 146/147 (detail), 159, 160/161 (detail), 165, 166/167 (detail), 168/169 (detail), 171, 172/173 (detail), 188 (detail), 195, 196/197 (detail), 198, 201, 202/203 (detail), 204/205 (detail), 211, 212/213 (detail), 214/215 (detail), 217, 218/219 (detail), 220 (down) , 223, 224/225(detail), 240.

Akg-images/Erich Lessing: 90, 104/105, 106/107 (detail), 108/109 (détail), 148 (detail), 155, 180, 229, 230/231 (detail), 232/233 (detail).

Akg-images/Rabatie-Domingie: 121.

Akg-images/Sotheby's:181.

BKP, Berlin, 2004, Distribution RMN: 28, 163 (right).

Bridgeman-Giraudon : 4/5, 31, 32/33 (detail), 84 (down), 102, 112 (detail), 135, 137, 151, 152/153 (detail), 183, 185, 187, 207, 208 (detail), 220 (up), 226, 237, 238/239 (detail), 251, 252/253 (detail).

Bridgeman-Lauros-Giraudon: 37.

Fondation Custodia: 16 (up).

National Gallery, London: 15,92 (detail), 110.

National Gallery of Art, Washington: 175, 176/177 (detail).

The Frick Collection, New-York : 57, 58/59 (detail), 60/61 (detail), 117, 118/119 (detail), 191, 192/193 (detail).

The Metropolitan Museum of Art, New-York: 51, 52/53 (detail).

Printed by Grafiche Zanini
Bologna, Italy,
September 2004.